fast ART

to mum and dad... with love xx

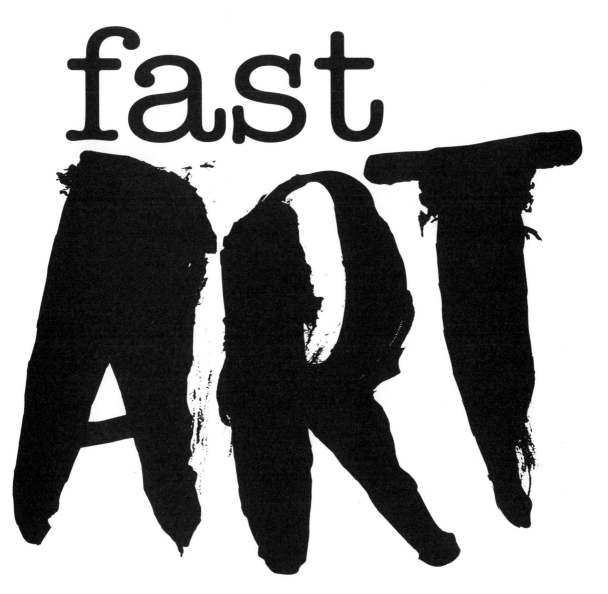

fast ART

#30projects#creative#inspirational#quirky#fun#

BEV SPEIGHT

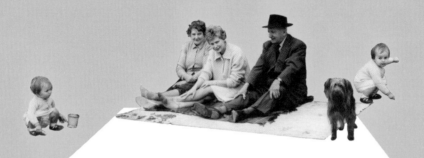

An Hachette UK Company
www.hachette.co.uk

First published in the United Kingdom in 2018 by
ILEX, a division of Octopus Publishing Group Ltd
Octopus Publishing Group, Carmelite House,
50 Victoria Embankment,
London, EC4Y 0DZ
www.octopusbooks.co.uk

Design and layout © Octopus Publishing Group 2018
Text and illustrations © Bev Speight 2018

Distributed in the US by Hachette Book Group
1290 Avenue of the Americas, 4th & 5th Floors
New York, NY 10104

Distributed in Canada by Canadian Manda Group
664 Annette Street, Toronto, Ontario,
Canada M6S 2C8

Publisher: Roly Allen
Editorial Director: Helen Rochester
Managing Editor: Frank Gallaugher
Senior Editor: Rachel Silverlight
Publishing Assistant: Stephanie Hetherington
Art Director: Julie Weir
Designer: Bev Speight
Production Controller: Meskerem Berhane

ISBN 978-1-78157-515-4

A CIP catalogue record for this book
is available from the British Library

Printed and bound in China

10 9 8 7 6 5 4 3 2 1

whitby beach
(vintage photograph, coloured paper)

contents

introduction

This is it – my collection of eclectic, quirky fine-art projects to try right away. From tape art and land art to contemporary collage and the bizarre world of sticky notes, I hope the projects within these pages will help you generate ideas, and guide you to explore and develop your art practice, whatever stage you're at.

And, as the title suggests, these projects are fast. They're designed for speed and spontaneity, because fast art is stunning art. When you make something quickly, you avoid overthinking and take more creative risks. You make original artwork that's fresh and experimental. As an art educator, I see this in practice nearly every day as students begin to trust their ideas and push themselves beyond what is familiar into new, exciting territory.

These 30 projects have hidden challenges: choosing colour combinations, experimenting with urban surfaces, inventing new ways to create marks and decorative detail, working with materials such as wax and wire – and more. They don't demand fancy equipment; you just use everyday stuff that you can get your hands on quickly.

Enough of the introduction. Let the **Fast Art** begin!

brief

Each art project starts with a <u>creative brief</u>, giving
clear goals to follow and visual prompts with inspiring
examples to get you started. Use the examples to help
clarify your task and think about how you can create
your own original version to answer the brief. These
projects will stretch your imagination through artistic
techniques, from drawing and collage to sculpture and
photography. Learn by example, be inspired by what you
see and be encouraged to look and research further.

Look out for the <u>photography challenges</u> - they're a simple
and effective approach to kick-starting any project. They
invite you to focus on a subject in detail and explore
different visual interpretations rather than the obvious.

You can work through the book from beginning to end or
dip in and out as you wish.

Explore, experiment and enjoy your creative journey!

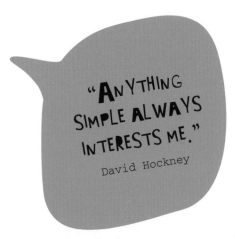

"ANYTHING
SIMPLE ALWAYS
INTERESTS ME."
David Hockney

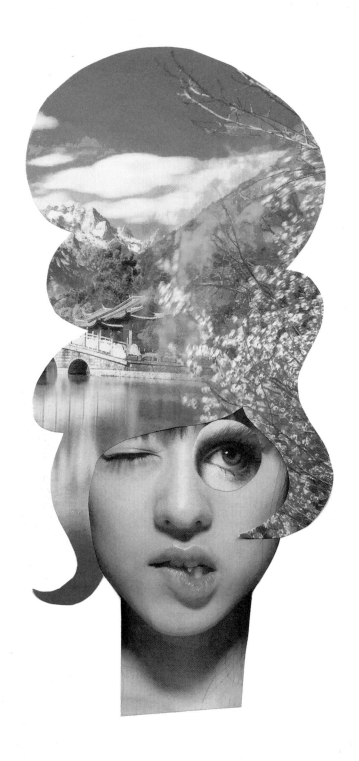

turn your magic on...
open your head to ideas and
be inspired by what you see.

The projects in this book have been inspired by great artists and designers of the world.

Research and exploration are a major part of learning and it's good to look around you for ideas. No idea is completely original and all artists look to what has come before for inspiration, putting their own twist on it to produce their own creative outcomes. Go with your own findings and discoveries to create something new and fresh.

Show off your art! In minutes
you can produce creative
outcomes, capture the results
on a camera and upload.

Social media provides a platform
for artists to promote their art:
a worldwide gallery to display
art creations. Become an artist-
in-residence from your own home.

#01. glue, paper, scissors

Brief:

There's a collage revival going on, with some fantastic contemporary artists taking collage in a new direction. You will also find great inspiration by looking at pioneer artists like Hannah Höch. In our digital world, where the majority of images we see are created on a computer, it's refreshing to see a return to traditional methods. Collage is all about composition and careful selection. There are no rules, and the combination of materials and found images provides an endless source of visual interpretation.

A strong image and flat colour combination can produce a mesmerising picture. Get out your old photographs and vintage magazines and start by selecting a powerful image. Carefully cut it out. By taking out the surrounding detail and replacing it with simple flat-colour shapes you can change the context of the original piece or tell a story: turn a beach background into sea, create a black hole for your subject to disappear into, put unlikely combinations together or simply create an abstract composition with complementary colours. Experiment and have fun, remembering to keep the composition strong and simple.

All you need is glue, paper and scissors, and a good source of imagery.

"When the subject is strong, simplicity is the only way to treat it."

Jacob Lawrence

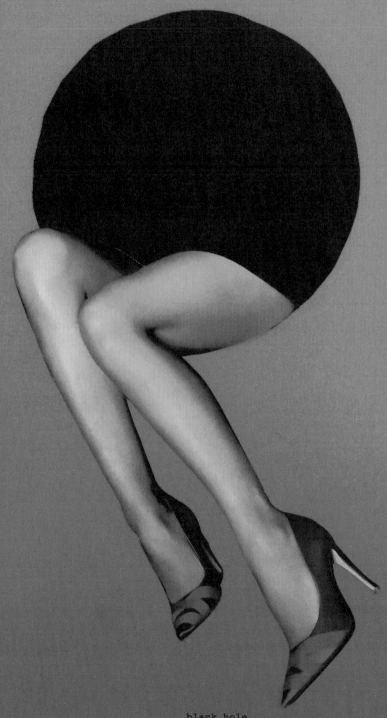

black hole
(magazine, coloured paper, glue)

Yorkshire sheep
(magazines, coloured paper, glue)

Vary your edges by
experimenting with
straight cuts or
torn edges – make
your choice based on
what concept you are
trying to portray.

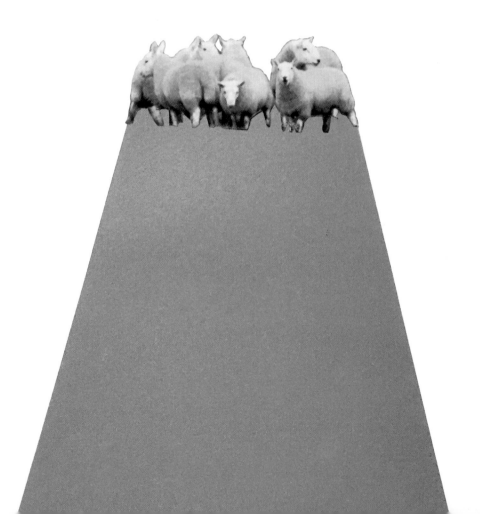

tin plane
(magazine, coloured paper, glue)

#02. pulling faces

Brief:
This is a photography challenge! So get out your cameras –
a phone camera will do – and be on the lookout for faces...

Pareidolia is a term used to describe the experience of
seeing faces, patterns or images in our surroundings, such
as in clouds, rocks, trees etc. There are been many examples
of perceptions of imagery in everyday places: from animals
in clouds to the face of Christ on a piece of toast!

We are searching for expressions. Look closely at the world
around you for faces peering back. Take a walk through urban
life, domestic settings or natural environments; the beach,
the countryside, urban streets, city architecture, everyday
objects. Scout your kitchen cupboards. Search tree branches
for a smile, the garage door for a wink, or maybe an angry
stare will appear among the plant pots. Consider the
background to your face and how you might frame it. Think
about how you crop the image within your view: get close,
discarding the bigger picture to capture a detail and
emphasise the features.

Display your images
together within
a structured
composition or grid.

16

"WHO SEES THE
HUMAN FACE CORRECTLY:
THE PHOTOGRAPHER,
THE MIRROR OR THE
PAINTER?"

Pablo Picasso

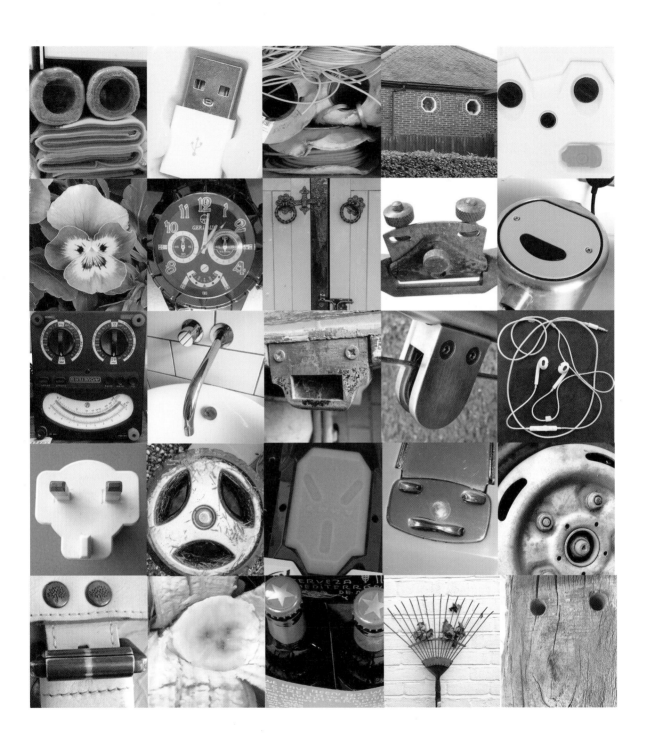

friends
(phone camera)

#03. tape-art perspective

Brief:

Tape art was born in the '60s. It's a temporary art style that can portray decoration, concept and form. Generally, this instantaneous art form sees artists working quickly, applying their tape visuals to urban surfaces and capturing outcomes with photography, before removing without a trace.

With a contemporary twist on traditional tape-art methods, this project plays with pre-made moveable tape images constructed indoors, before being transported and temporarily fixed to interesting backgrounds, textures and perspective locations.

Image creation should be kept simple. Use tape as a drawing implement. Tape your image directly onto card to give support and rigidity to the shape. Carefully trim the card to reveal only the tape image. Use removable low-tack adhesive to secure your tape constructions in position on your chosen surface, photograph and remove.

Take a walk, looking for textures, surfaces and situations to use as a base for your tape-art creations: pavements, floors, walls and pathways. Or move no further than your own doorstep. Simple constructions, applied in the right setting, can produce magical and surreal outcomes.

opposite: flap
(tape, card, pen, paper)

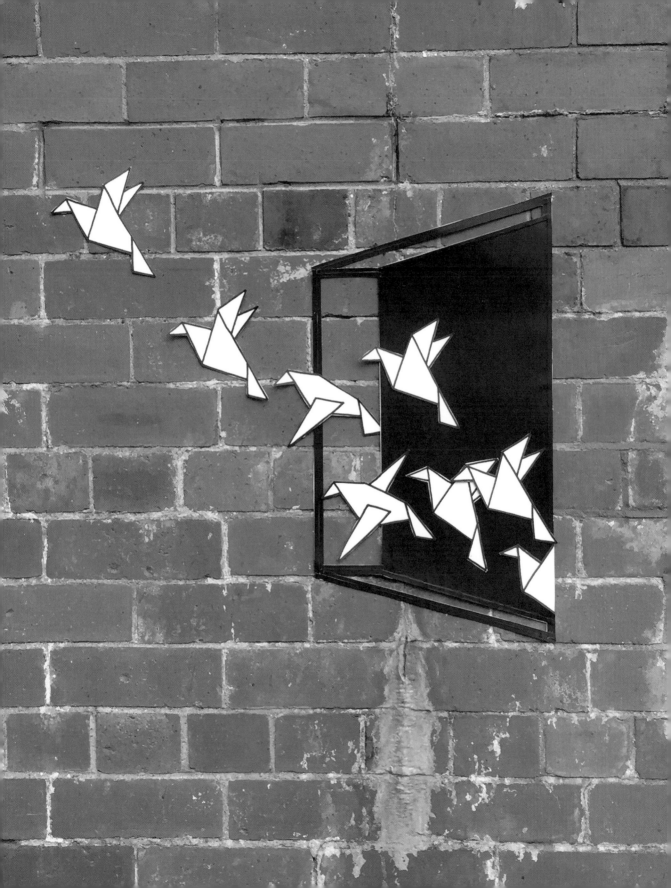

Making portable tape art.

1.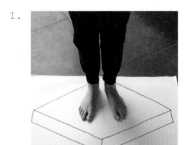

2.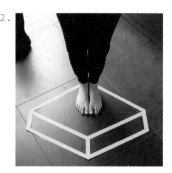

3.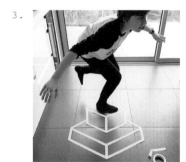

4.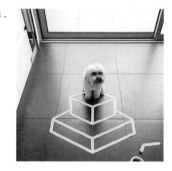

Get a
friend to
help you.

5.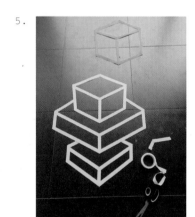

6.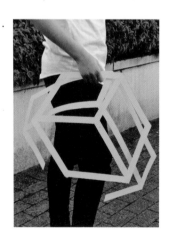

All you need is
tape, card and
scissors to create
movable card-backed
tape geometric
shapes.

1. Plan out the
shape and sketch in
pencil onto a piece
of card

2. Tape the shape.
Keep it simple with
3D geometric shapes
and then trim it
out, ensuring the
card backing is
disguised by the
tape image.

3./4./5. Add more
shapes and build
your illusion.
Vary the colour.

6. Transport your
cutouts to an urban
setting and play
with the illusion.
Think about the
background of your
shot - lines to
give perspective
work well. Once
you find a suitable
urban surface,
arrange your artwork
and capture it with
your camera.

opposite: balance
(tape, card, scissors)

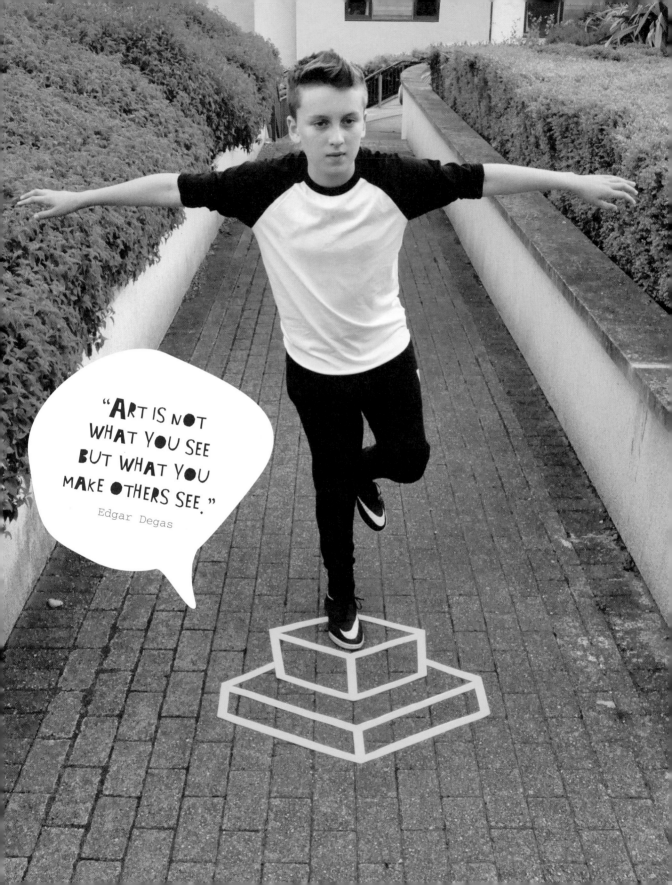

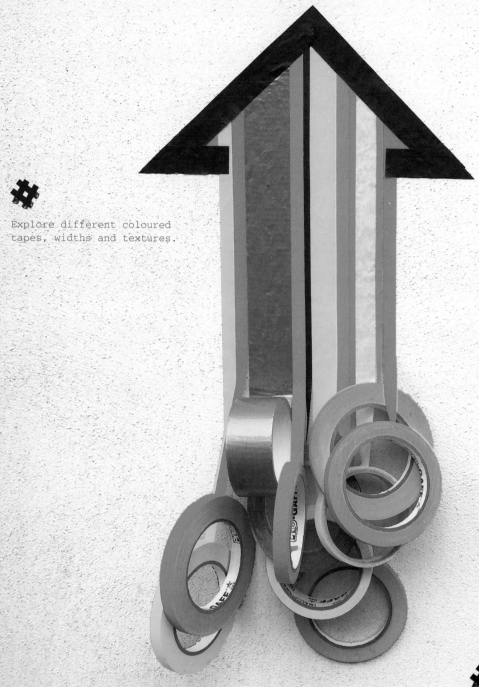

Explore different coloured tapes, widths and textures.

Backgrounds or settings with perspective help to enhance the illusion and add depth to your final photograph.

above: drip
opposite: pink cube
(tape, card, scissors)

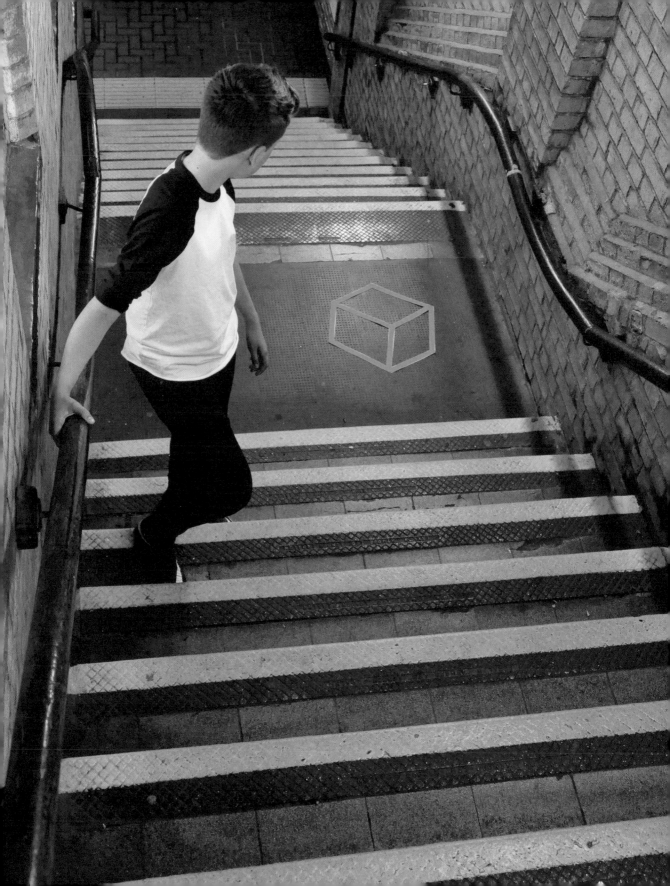

#04. eyes wide shut

Brief:

Eyes fixed and concentrating on the subject you are drawing - don't look down! Aka <u>blind contour drawing</u>. A great way to train your eyes to draw what you see rather than what you think you see. Your hand and eyes work as a team and you look at your subject in more detail.

Choose your drawing tool: felt-tip, ballpoint pen or pencil. Start by outlining your subject, drawing a continuous line, without looking or lifting your pen off the paper. Work slowly. We're not looking for perfection; enjoy the unique quality of line this technique produces. This process doesn't allow you to be too precious with your line, giving freedom to your drawing. A great exercise to loosen up tight drawing. Liberating!

Blind contour drawing is a technique introduced by Greek- American camouflage artist Kimon Nicolaides (1891-1938) during the First World War.

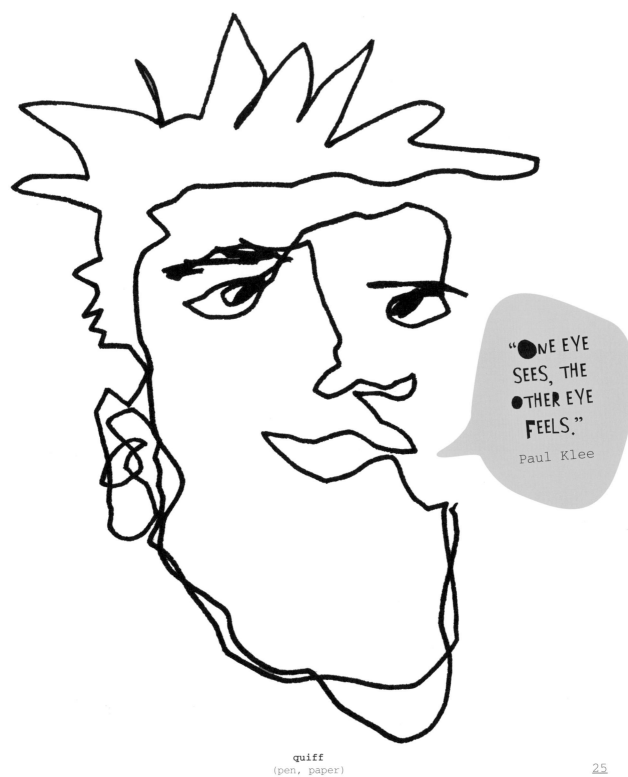

quiff
(pen, paper)

Vary the thickness of your lines and experiment with different coloured and textured papers.

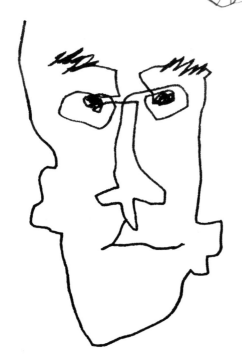

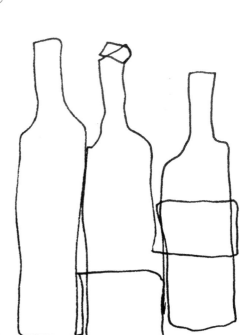

mix
(pens, pencils, paper)

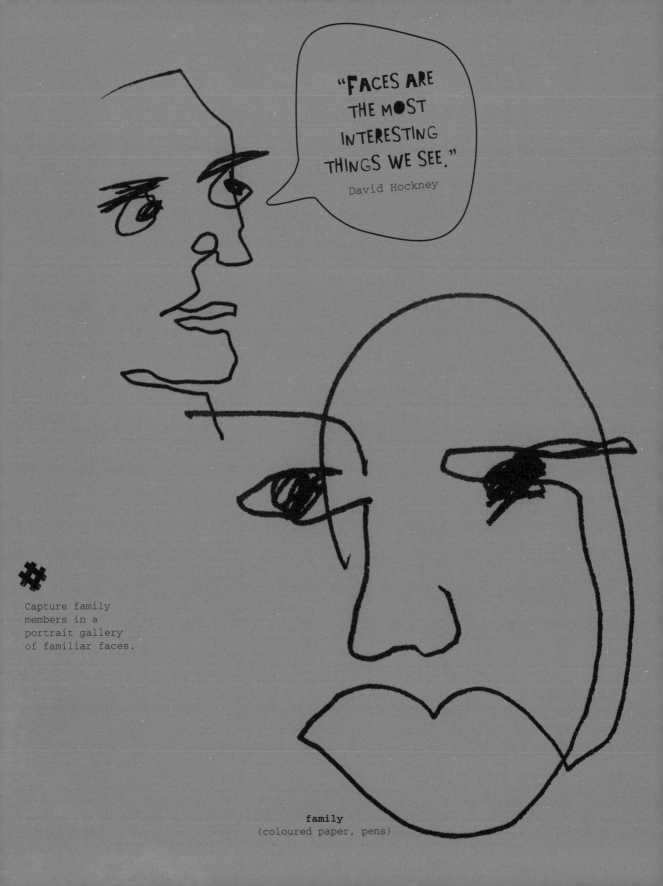

"FACES ARE THE MOST INTERESTING THINGS WE SEE."
David Hockney

Capture family members in a portrait gallery of familiar faces.

family
(coloured paper, pens)

#05. connections

<u>Brief:</u>
Take inspiration from Charles and Ray Eames' 1950s *House of Cards* – a series of interlocking cards that can be put together in many different formations to create a 3D sculpture. The slotted cards provide a device for combining and displaying an assortment of imagery on both sides of the cards.

This project takes 2D into 3D by producing simple <u>interlocking cards with different surfaces and shapes that combine to form a sculpture.</u> Using this construction idea, make yourself a set of cards. They don't have to be rectangular; maybe try circles, squares or irregular shapes (see templates on page 32).

Collect and create imagery to adorn the cards. You could use photographs, patterns, drawings or simply colour combinations. You have a few things to decide. Do you want to use colour or only black and white? Will the surfaces combine to make a complete image? How about a collection of facial expressions throughout the cards, or different features on each card that combine to make a face? Alternatively, you could introduce optical patterns to the cards to give depth and contrast.

Construct and experiment with different combinations and photograph your sculptures.

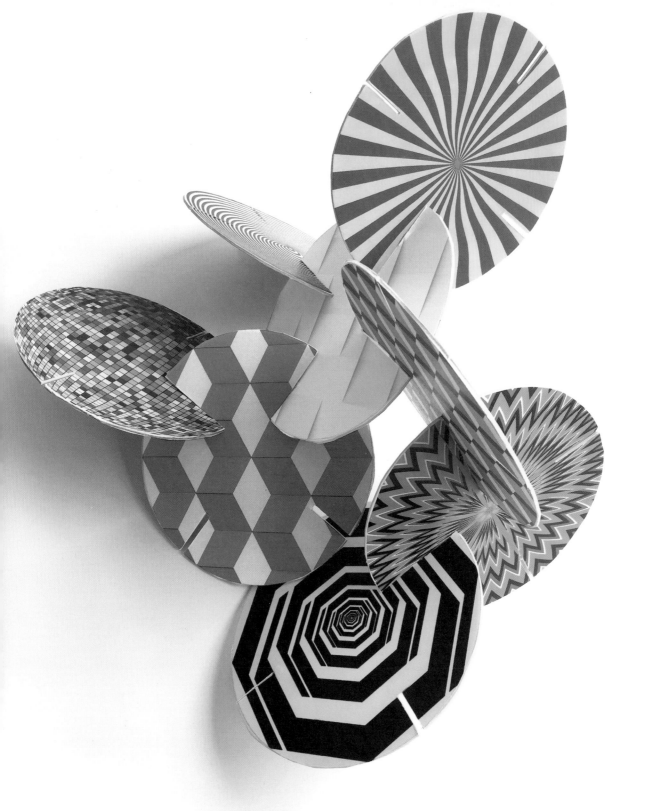

πr² by cath speight
(printed patterns, paper, card, glue)

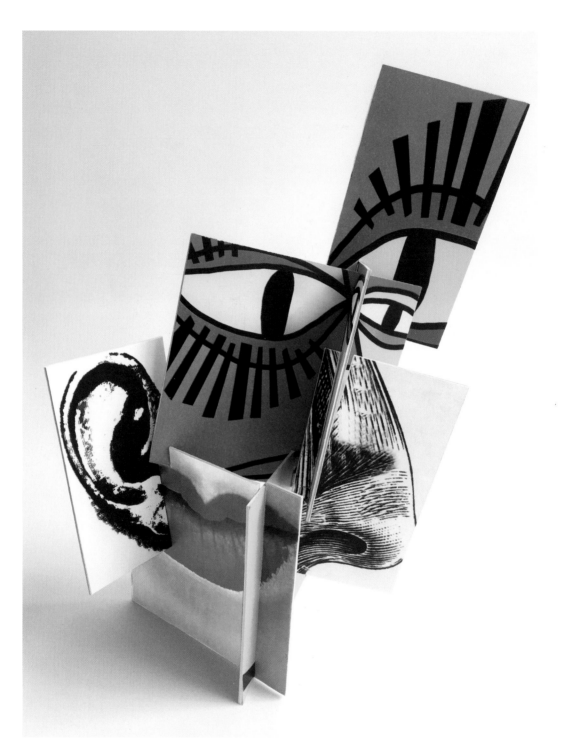

multicultural by cath speight
(photocopies, card, glue)

Search for facial features and put them together to form a complete face of cards. These images are taken from a mix of sources - photograph, drawing, painting, collage. You could use photocopies of favourite photographs of your friends and family to make your sculpture more personal.

Experiment with different-sized cards or keep them all a uniform size. The cards fit together by linear slots cut in their edges. The length of these slots can vary so that when they fit together, some cards can sink deeply into the next and others perch on top.

Photographing your sculpture from different angles can dramatically change the face and distort the features.

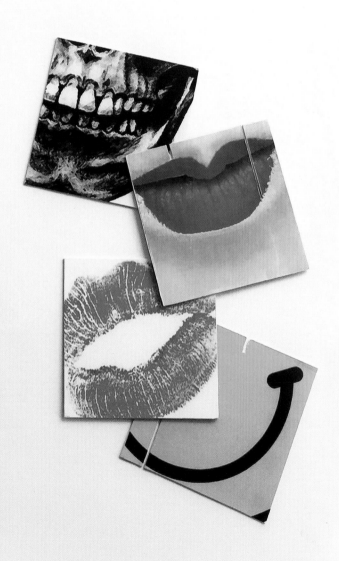

A selection
of basic card
templates
for you to
photocopy and
use for your
cards. Or
create your
own.

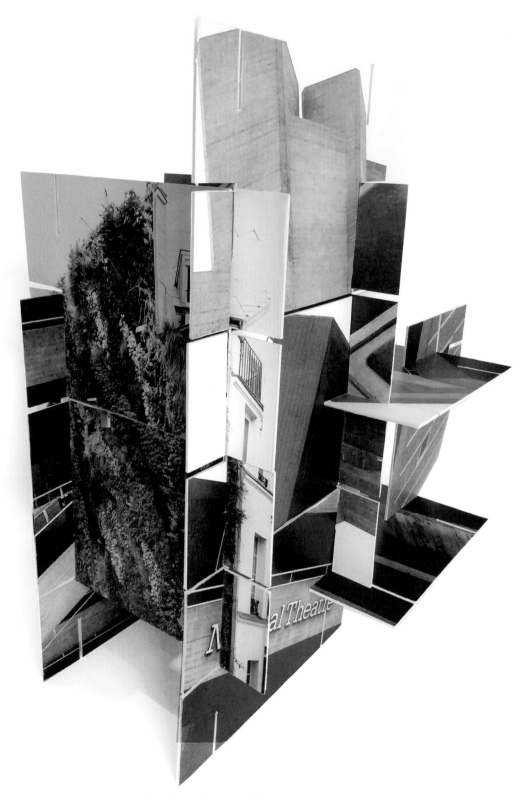

brutalist by alfie mcmeeking
(printed photographs, card, glue)

#06. fashionista lookbook

Brief:

It's all about ideas and having fun with materials: a wedding dress made from folded tissues, a nature-inspired skirt of leaves, a red pompom cocktail dress, a headpiece made from feathers, burnt matches for a skirt... Work small and work fast, playing and experimenting as you go.

There are two parts to this project: creating your model (or mannequin) and putting together your experimental fashion collections.

Part one: Create your mannequin in a style that's personal to you. A simple stick drawing is fine to get you started, or you can try stitched legs, a curved line, collage faces, even animal heads - just keep it simple. This will be your base model on which to apply your designs.

Part two: Dress your model. Think about shapes, contours, pattern and colour. Collect materials to work with: patterns from magazines, fabric from the charity shop, garish plastic carrier bags - any interesting materials from around the house or garden, or even from the streets.

Now apply your designs to your base templates. Work quickly and spontaneously. Photograph as you go - it will be interesting to look back at the decisions you made as the designs evolved.

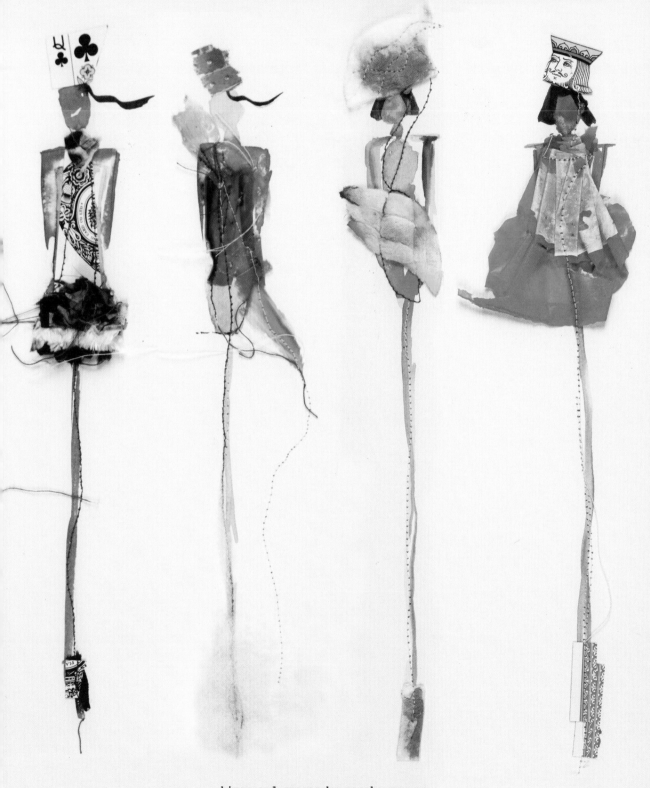

kings and queens by manako gurung
(mixed media)

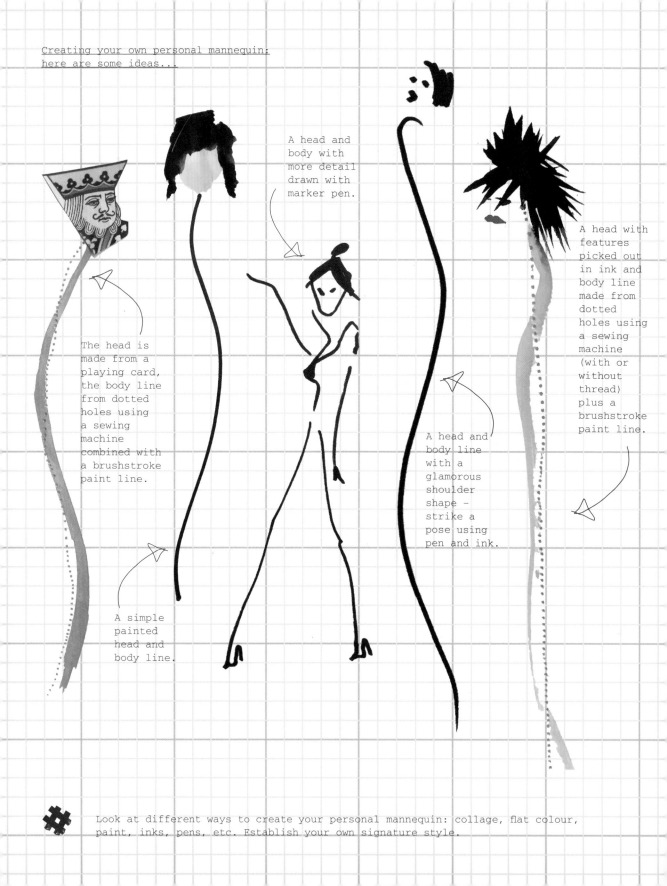

Creating your own personal mannequin:
here are some ideas...

A head and
body with
more detail
drawn with
marker pen.

A head with
features
picked out
in ink and
body line
made from
dotted
holes using
a sewing
machine
(with or
without
thread)
plus a
brushstroke
paint line.

The head is
made from a
playing card,
the body line
from dotted
holes using
a sewing
machine
combined with
a brushstroke
paint line.

A head and
body line
with a
glamorous
shoulder
shape –
strike a
pose using
pen and ink.

A simple
painted
head and
body line.

Look at different ways to create your personal mannequin: collage, flat colour,
paint, inks, pens, etc. Establish your own signature style.

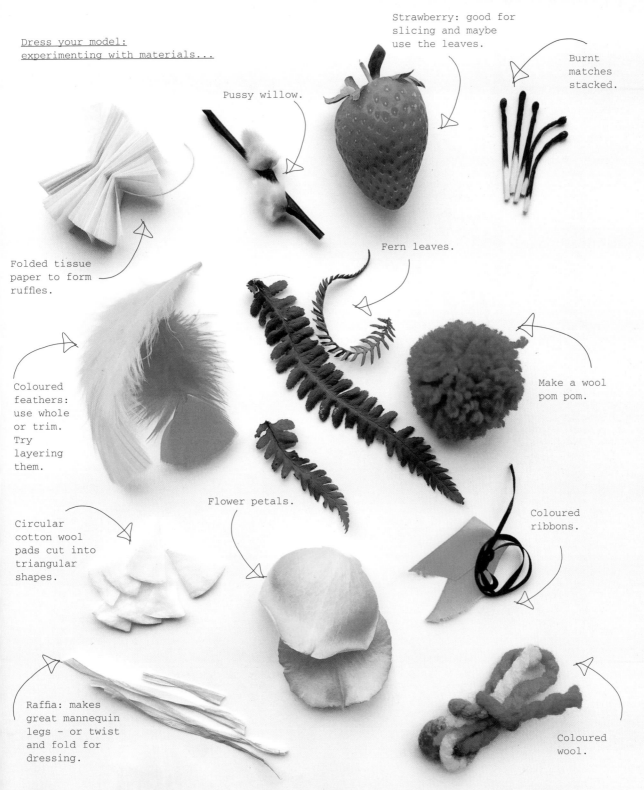

Dress your model:
experimenting with materials...

Strawberry: good for slicing and maybe use the leaves.

Burnt matches stacked.

Pussy willow.

Folded tissue paper to form ruffles.

Fern leaves.

Coloured feathers: use whole or trim. Try layering them.

Make a wool pom pom.

Circular cotton wool pads cut into triangular shapes.

Flower petals.

Coloured ribbons.

Raffia: makes great mannequin legs – or twist and fold for dressing.

Coloured wool.

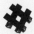 Try experimenting with materials and techniques such as plastics bags, crumpled paper, cotton wool dipped in coloured inks... Also try plants, flowers, fruit and vegetables as well as household items and haberdashery. What else could you use?

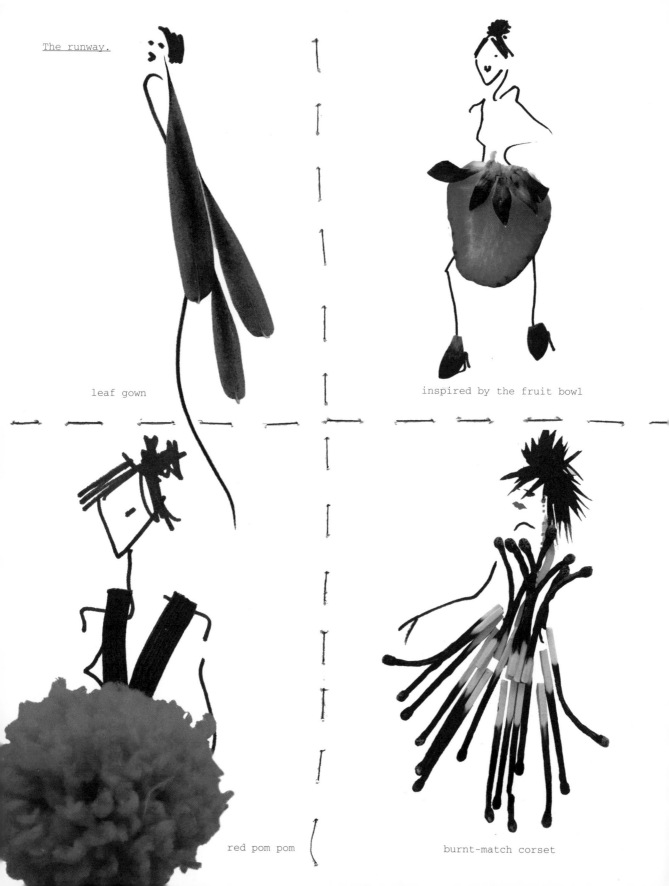

The runway.

leaf gown

inspired by the fruit bowl

red pom pom

burnt-match corset

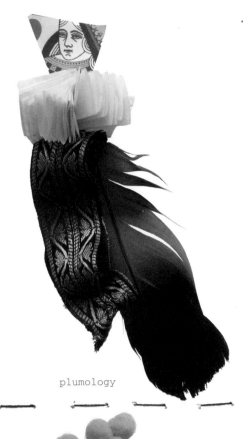

plumology

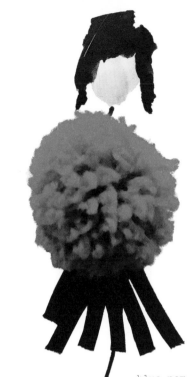

blue pom pom

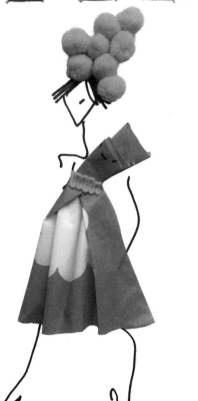

carrier bag dress

"ALWAYS KEEP
YOUR EYES OPEN.
WHATEVER YOU
SEE CAN INSPIRE
YOU."

Grace Coddington

#07. change one thing

Brief:
Collage is the art of using found imagery. It's an exciting process of finding, sorting, selecting and transforming an existing image to give it an exciting new purpose. This mixed-media, modern visual art form has history. Picasso used found images during his cubist period; Peter Blake famously collaged the cover of the Beatles' 1967 album *Sgt. Pepper's Lonely Hearts Club Band* and there are many more fantastic contemporary collage artists all with fresh and individual approaches.

We're looking to <u>create a simple but dramatic collage</u> by choosing one image and adding or removing just one thing to change the meaning or story of the original artwork, creating a new one.

Start by selecting and cutting out your images. Once you're happy with the composition, then photograph for reference in case things move when you begin to glue each piece in place, then capture your final artwork.

"CREATIVITY TAKES COURAGE."
Henri Matisse

opposite: geoffrey
(magazines, glue)

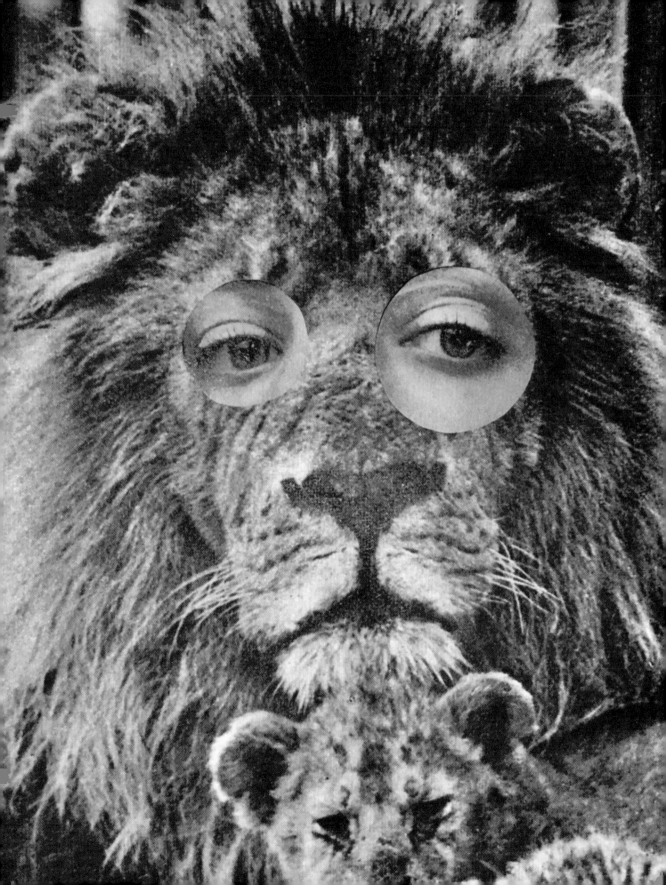

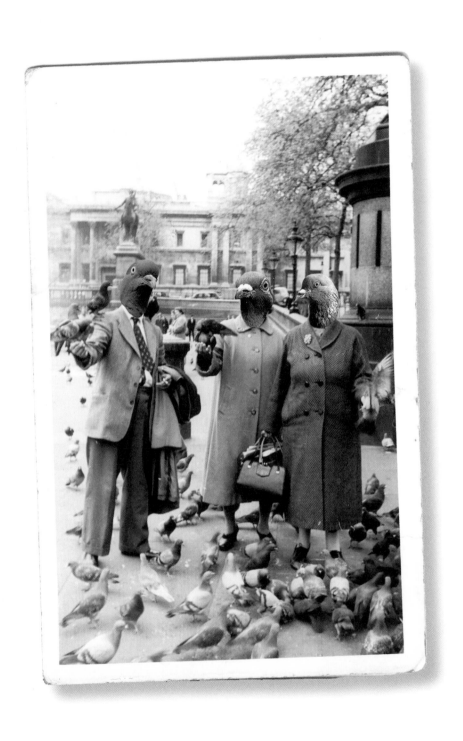

stanley, nellie, ethel
(vintage photograph, magazine, glue)

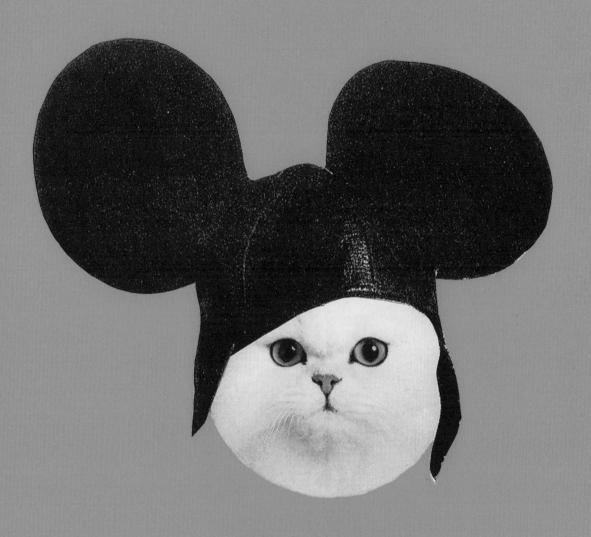

cat and mouse
(magazines, coloured paper, glue)

Vintage photographs and magazines are a great source of imagery.

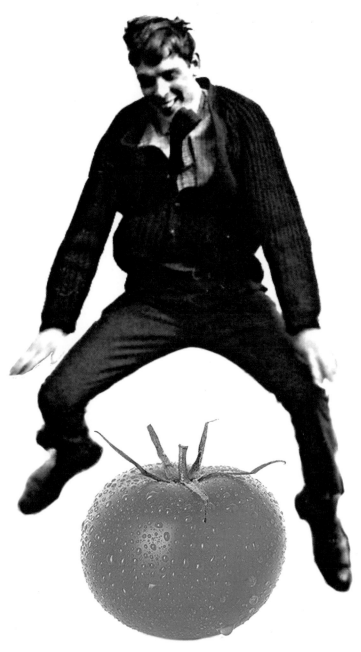

opposite: explosive mix
above: jump
(vintage photographs, magazines, glue)

#08. invisible drawing

Brief:

Wax candles make interesting drawing implements. The wax gives an invisible, spontaneous and unpredictable quality to drawings, with amazingly fluid results. White candles work well cut into small, manageable 2-3 cm pieces, giving more control. Be bold and confident with your drawing, pressing firmly with the wax onto watercolour paper.

The wax creates a barrier on the paper surface so that it stops the paint from sticking to its surface. Pressing lightly will put less wax on the surface. If it's textured paper rather than smooth you will get a broken edge of white. Experiment with different papers.

Create your image with simple, bold, confident lines with the wax block. Then wet the paper lightly with clear water to make the surface receptive and even. Using a wide paintbrush and paint or ink, introduce a very light wash over the surface. The invisible becomes visible as it resists the paint, leaving the white paper to identify the marks. Don't forget that the wax is permanent - you can't remove it and you can't paint over it

"YOU MUST PLAN TO BE SPONTANEOUS."
David Hockney

opposite: glance
(wax, paint, watercolour paper)

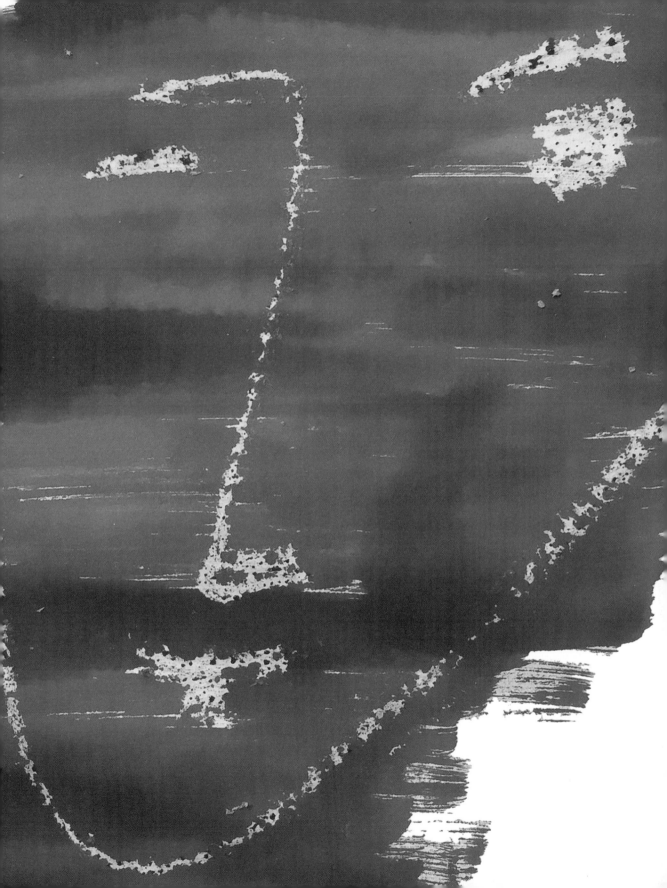

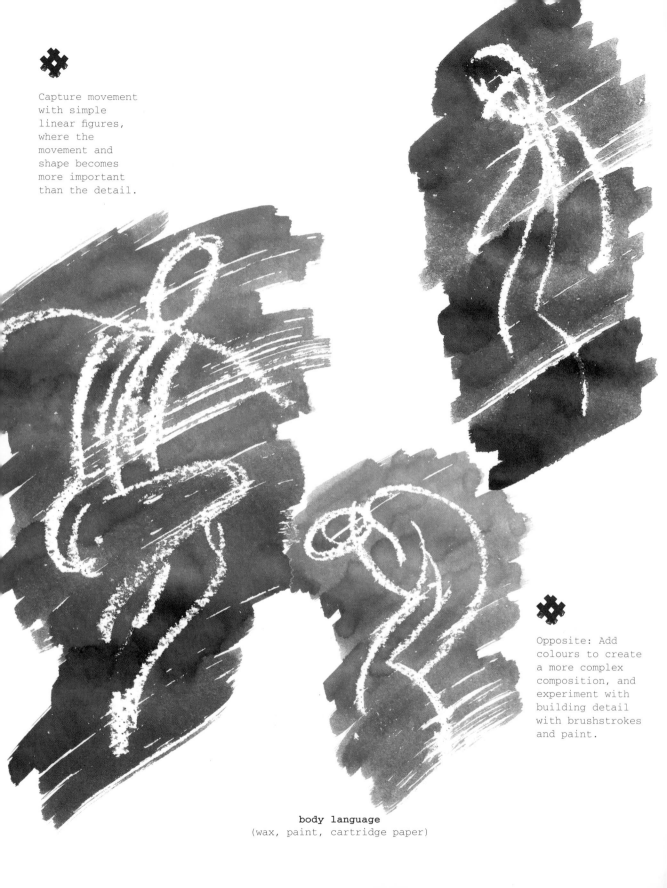

Capture movement
with simple
linear figures,
where the
movement and
shape becomes
more important
than the detail.

Opposite: Add
colours to create
a more complex
composition, and
experiment with
building detail
with brushstrokes
and paint.

body language
(wax, paint, cartridge paper)

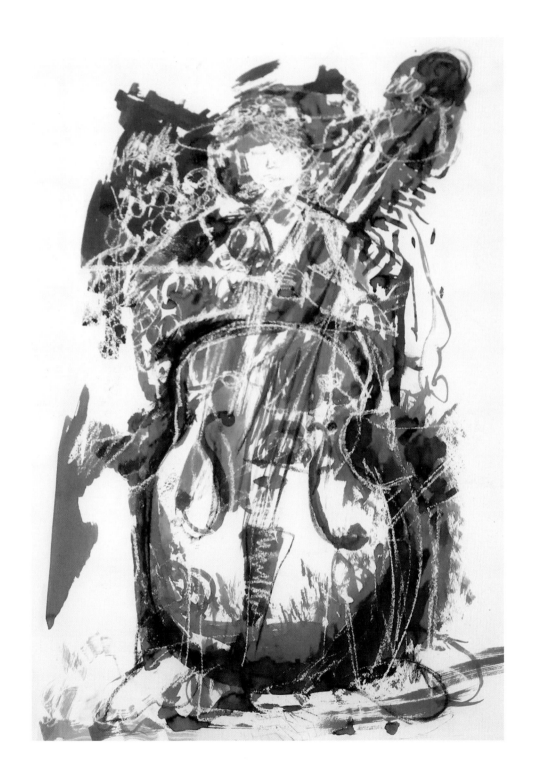

the cellist by chloe price
(wax, paint, cartridge paper)

#09. take a peek

Peephole dioramas offer a captivating peek inside another world. These three-dimensional miniature scenes are created within a box or container with a peephole through which to view the artwork presented within. The restricted view adds to the surprise and voyeuristic pleasure of the viewer. The artwork within takes its perspective from the size and position of the viewing hole.

There are three parts to this project: choosing a container, creating a visual artwork within the container and capturing a view of the scene with your camera.

Watch your ideas transform from 3D to a uniquely effective 2D image when you capture a glimpse of the artwork with your camera. Work quickly, playing and experimenting as you go.

Opposite: The view through a hole punched in the side of a shoebox reveals the magical hand-drawn alien world inside. Suddenly the box becomes irrelevant and the outcome depends solely on the vision framed by the hole creating intrigue and perspective.

"LIFE IS A PEEPHOLE, A SINGLE TINY ENTRY INTO VASTNESS."

Yann Martel

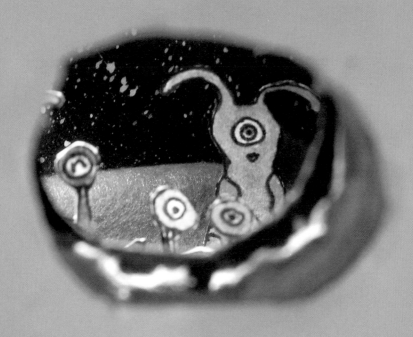

planet lobo by ishaa lobo
(shoebox, paper, felt-tip pens, glue, scissors, camera)

Choose your container to complement the visual idea you plan to create inside.

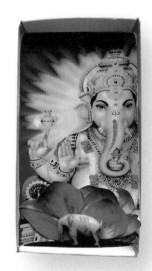

Here is a mixture of peephole views and open boxes which contain a great collection of little worlds. The open approach to the diorama allows more scope for detail and depth to be on show, but still within the confines of a small space.

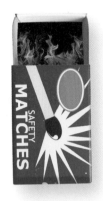

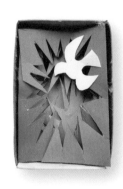

Use a variety of materials to create your visual: everything from photocopies and old photographs to 3D ornaments. Experiment with papercraft as well as collage and painting.

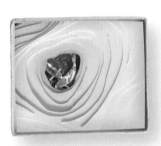

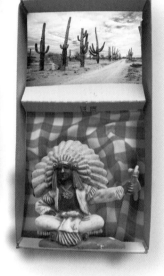

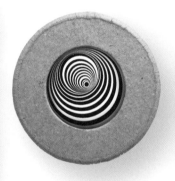

Peep in with your camera and capture.

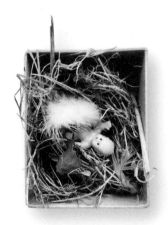

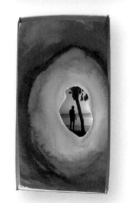

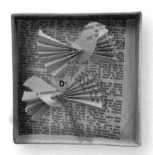

take a peek
(boxes and lids, paper, magazines, newspaper, vintage ephemera, photocopies, scissors, glue, fabric, wire, old photographs, paint, boxes)

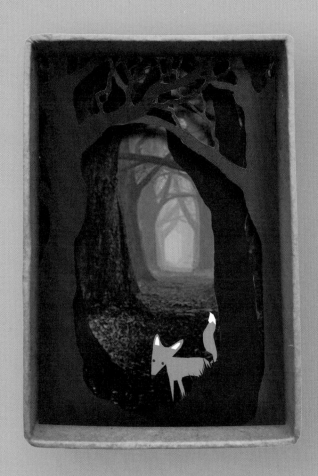

An example of multi-
layered imagery
creating a sense of
depth; combining
a background with
mid-ground layers
and detail in the
foreground.

fantastic mrs fox
(coloured paper, photocopies, scissors, box)

#10. letter search

Another example of pareidolia (see page 16). Pareidolia
is the name for the phenomenon of seeing faces, patterns,
letters, images and so on in clouds, rocks, trees, coffee
spills, etc. Leonardo da Vinci wrote about pareidolia as an
imaginative device for painters, and there have been many
instances of perceptions of imagery in everyday places.

We are searching for letterforms. Look closely at the world
around you, wherever you are. City, country, at home or on a
train...

Search metalwork for a 'Y', cracks in the pavement for an
'S', or an 'M' might appear in the back of a chair. Capture
them with your camera phone. Think about how you will
crop the image – close around the letter form? Or wider to
include some background details, placing the letter within
a scene?

"THOSE WHO
DO NOT WANT
TO IMITATE
ANYTHING,
PRODUCE
NOTHING."
Salvador Dalí

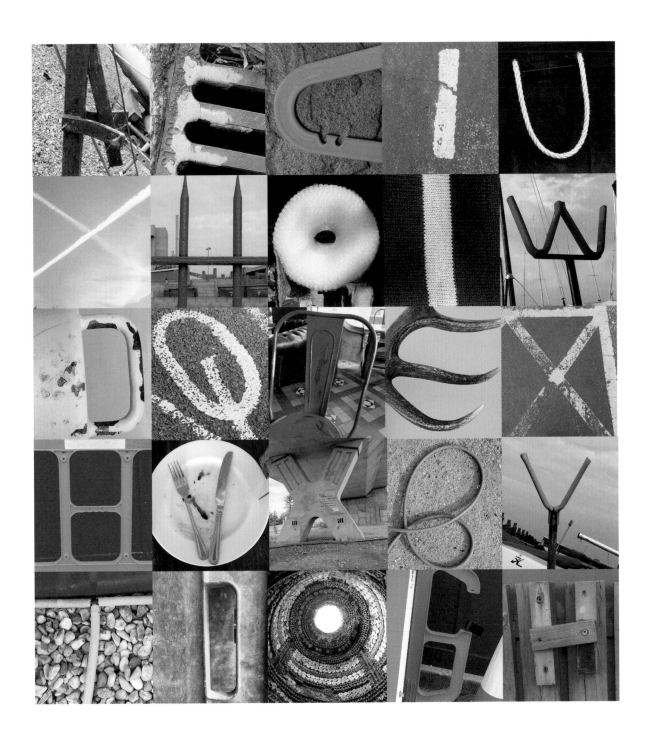

letters
(phone camera)

#11. kaleidoscopic collagist

<u>Brief:</u>
Create a kaleidoscopic collage that plays with morphed images, pattern and symmetry. Think Victorian cased butterflies, geometric shapes and Gilbert and George kaleidoscopic artworks. It's all about selecting strong images, then mixing and multiplying to create a <u>symmetrical graphic arrangement.</u>

Start by choosing two images. They can be <u>formulaic</u> or <u>random</u>, either way, set yourself search boundaries: a family portrait and an animal, favourite food and a body part, similar-shaped objects, such as a planet and an apple, morphed together, or let your random choice of attractive and interesting images dictate the combination.

Carefully cut out your images and combine them to create your collage element, sticking them together with glue. Multiply the spliced image with a photocopier. Using your identical images, start to play with symmetrical arrangements. Drawing a grid may be useful, helping to ensure that the arrangement is accurate - use light pencil so that you can rub it out after. When you're happy with the pattern, stick the pieces in place and photograph.

Family
or vintage
photographs are
a great source
of imagery and
a good way to
avoid copyright
issues.

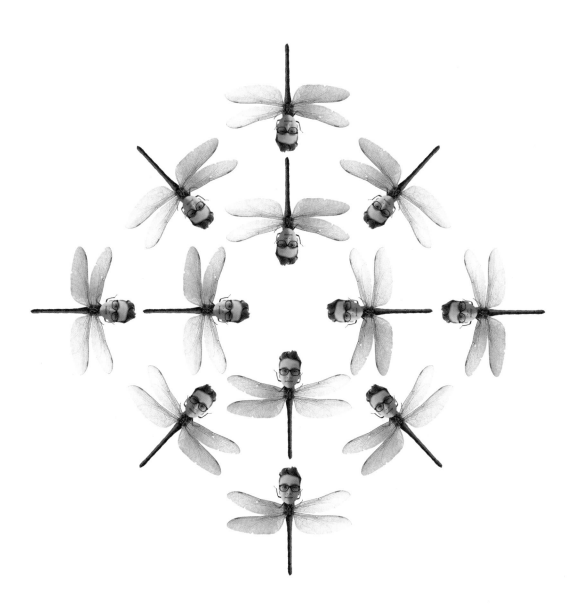

fly boy
(photocopies, scissors, paper, glue)

Make the pattern
more elaborate
by adding
more than two
elements.

Choose very
detailed images
with white
backgrounds,
such as the
beetles with
tiny legs, as
they can be cut
out roughly
and arranged
directly onto
a white paper
base. Once the
images are fixed
in place with
glue, the cuts
will blend and
disappear to
give a complete
image. This
process allows
for the use of
more detailed
imagery.

The finished
collage can be
reduced down
in size on the
photocopier to
give an even
more delicate
and detailed
artwork.

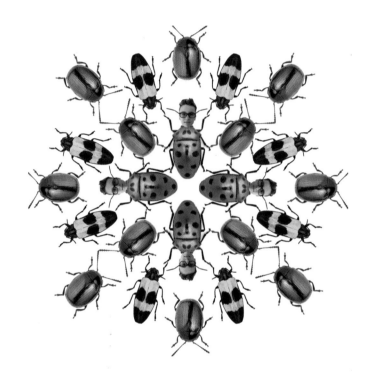

bug
(photocopies, scissors, paper, glue)

Alternatively, use
colourful cut paper
shapes. Invent new
patterns and colour
combinations.

space invaders
(coloured paper, scissors, glue)

#12. balance

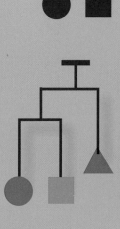

Brief:

Mobiles are kinetic three-dimensional sculptures that include moving elements and a balance of objects that appear to float in space. This is a deceptively simple project that involves a careful choice of shape, weights, colour and composition, combined with precise assembly. Be inspired by Alexander Calder's biomorphic mobile sculptures which combine natural and abstract forms, creating a sense of both order and chaos.

Here are some ideas to get you started. The mini diagrams show the point of balance on different configurations of shapes. It's a very experimental process with plenty of trial and error until you get the balance just right.

To start, you'll need bendable wire (a metal coat hanger will do), wire cutters, pliers for shaping, a collection of objects of varying weight or handmade wooden shapes and a sturdy base to anchor your structure.

"WHEN THE SUBJECT IS STRONG, SIMPLICITY IS THE ONLY WAY TO TREAT IT."

Jacob Lawrence

Opposite: A nature-inspired balance sculpture, using a coat hanger. A hole drilled in the heavy base pebble secures the balanced construction.

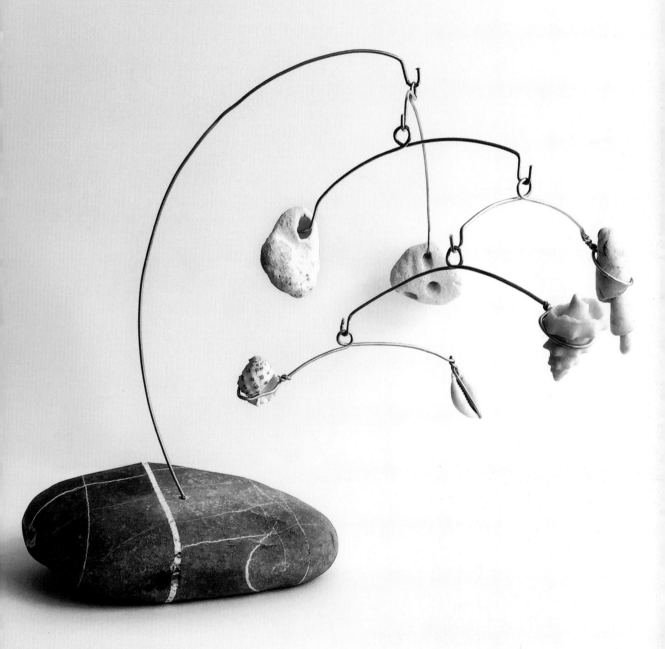

pebbles and shells by david midgley
(shells, coral, pebbles, metal coat hanger)

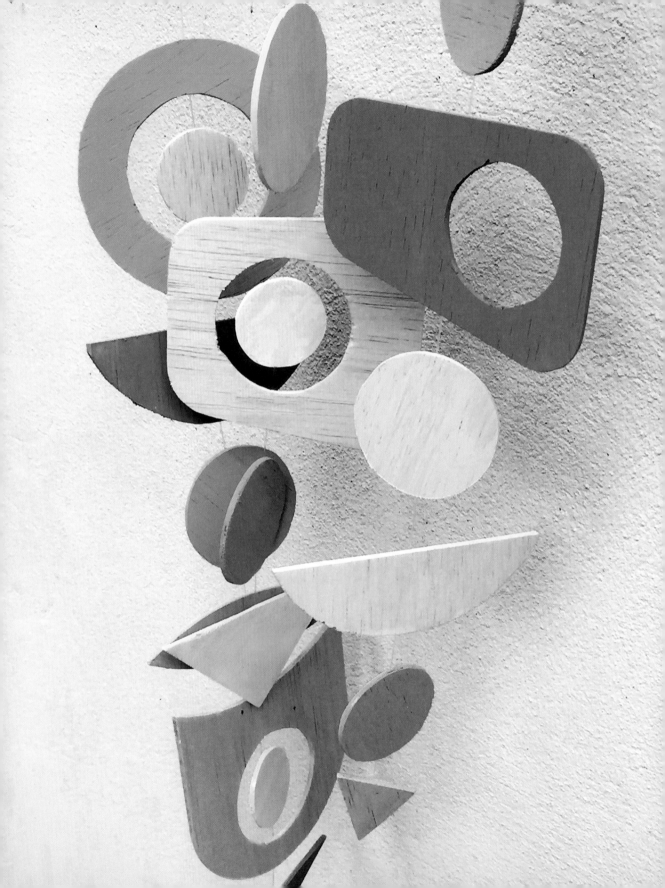

A hanging
construction of balsa
shapes. Balsa is a
soft wood easily cut
using a craft knife
(see page 124 for a
whole balsa project).
Sandpaper smooths and
refines the shapes
before painting.
Tape fine fishing
wire to the backs
of the shapes in a
line straight down,
ensuring the wire
is central. Arranged
in three lines, the
wires are attached
to a horizontal wire
or wooden stick. They
should hang freely.

Hang the arrangement
outside and capture
the arrangements on
camera moving as the
wind blows.

If needed, a small
amount of putty
can be added to
the bottom shapes
on each string to
weigh them down.
This should help
them hang straight.

This is a simple
arrangement but by
adding more shapes,
strings and cross
supports the design
will become more
intricate.

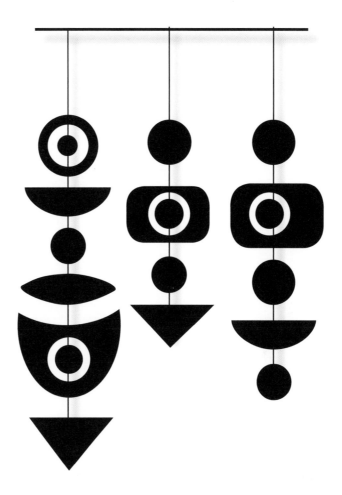

opposite: colour balance
(painted balsa wood shapes, fishing wire, metal coat hanger)

#13. white on white

Brief:

Monochrome artworks use only one colour. Many artists in the twentieth century experimented with making monochrome art. Italian artist Piero Manzoni painted a series of white-on-white paintings known as 'Achromes'. Look at monochrome artists for ideas*, and be inspired by the artworks on the following pages.

Experiment with folds and creases, textures and shapes and note how light plays a big part in the appearance of these images and can alter the dynamic if the direction or intensity of the light changes.

Create surfaces and textures with white materials that capture depth and shadow: use paper-cutting, sculpture and dry-embossing techniques. With white card, paper, string, paint, chalk, air-drying clay, embossing tools, plastic bags, scissors and glue begin to experiment with white on white. Take your finished artwork a stage further by photographing them with different light sources from different angles and at different intensities.

Opposite:
A light source and a simple loaded paintbrush can produce dramatic marks and contours.

*Indian artist Anish Kapoor, for example – he was apparently granted exclusive rights to use 'Vantablack' (supposedly the 'blackest black ever') in his artwork. This paint was developed by British company NanoSystems to use on stealth satellites as it reflects almost no light at all.

"THE DETAILS ARE NOT THE DETAILS, THEY MAKE THE DESIGN."
Charles Eames

white stripe
(paint, card, camera)

Experiment with folding strips of white card to create repeat 3D structures, which, when photographed on an angle, can produce connecting shapes. The same image captured from different angles can make a series of very different images. Be inventive.

selection of texture and shadow
(paper, scissors, glue, directional light, camera)

Playing with creases
and adding a familiar
element gives context.
Illustrate an idea
by adding reality
to your image — for
example, collage
planes.

skyfall
(paper, photocopies, directional light, camera)

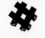

Simple dry embossing is a technique that raises a three-dimensional image on paper. All you need is an embossing tool, light box or torch, paper, masking tape and a firm surface. Experiment with different papers.

1. Start by drawing a simple design onto heavy card. Then cut out the shape and details: this will form your template.

2. Place your template between a flat surface and your white paper. Secure the template in place with a little pressure.

3. With your other hand, gently trace around the shape with your embossing tool. Push through the open parts of your design with the point.

4. When you have traced the whole image, take out the template to reveal an embossed replica of your design. Done!

1.

2.

3.

mustique
(paper, card, embossing tool)

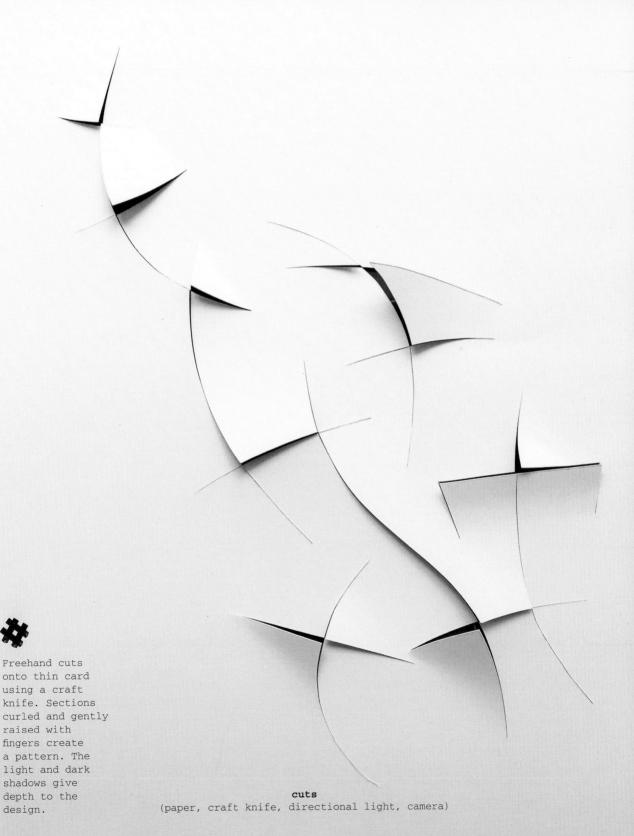

Freehand cuts onto thin card using a craft knife. Sections curled and gently raised with fingers create a pattern. The light and dark shadows give depth to the design.

cuts
(paper, craft knife, directional light, camera)

#14. missing pieces

<u>Brief:</u>

<u>Positive space</u> refers to the focus or subject of a picture. For example, positive space could be a vase of flowers in a still life painting, a person's face in a portrait or the trees and hills of a landscape painting. <u>Negative space</u> is the background or space around the subject.

<u>This project is all about the negative space.</u> Space can be just as important as the subject itself, and a deliberately missing element can become the most interesting part of a composition. Spaces add drama to what remains and helps draw focus to the detail.

Think about how you can use space to suggest an idea or enhance the information about the subject. The dark space opposite suggests a secretive midnight conversation and creates tension within the composition, for example. Using collage, take inspiration from the examples provided and see how creative you can be!

"MISSING PIECES DO MORE THAN COMPLETE THE PUZZLE, THEY FILL IN AN EMPTY SPACE."
Luanne Rice

opposite: see you again
(vintage photograph, black paper, glue)

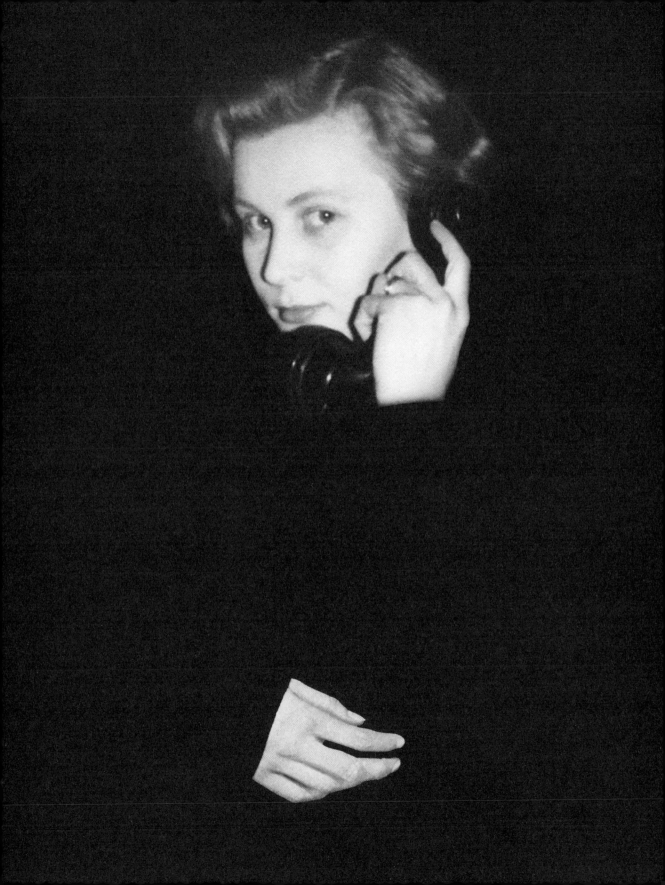

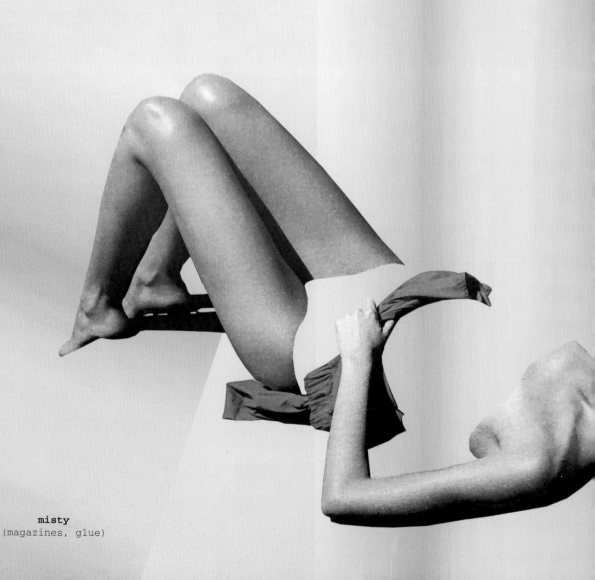

misty
(magazines, glue)

Opposite: The background
is made by patching
together different
sections of white room
images from magazines.
Details from the body
image are removed before
combining with the
background to form an
integrated image. The
open space suggests
peace and tranquillity.

Below: Have fun with a
torso. Use images from
magazines or photocopies
of old photos and remove
all but the torso, then
experiment with different
head replacements. Try to
illustrate a particular
personality or idea. It
could be anything you
want it to be, from a
fish head to a banana!

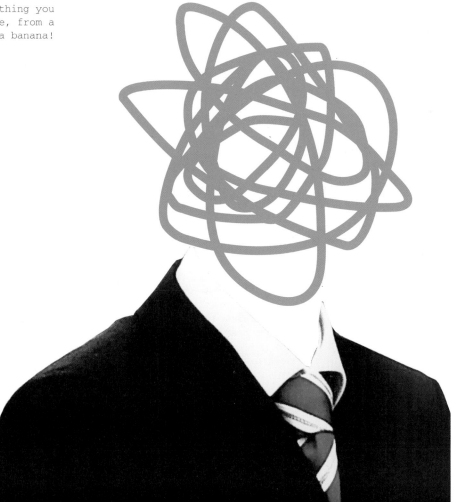

Right: Displace the space with another image. These images contrast and complement each other with the sepia and colour photo mix. If it's a familiar photograph the replacement image can tell a story by adding information about the character.

Photocopies of personal photographs save cutting up precious prints.

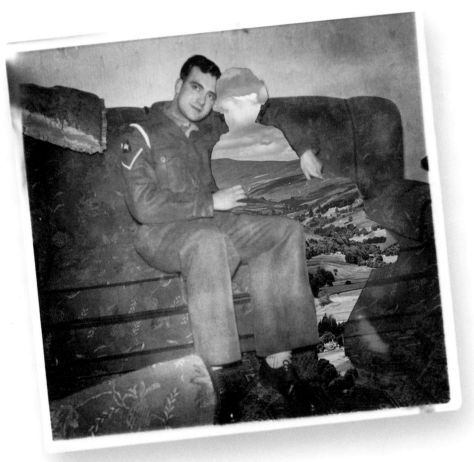

Opposite: Try an optical illusion effect by cutting out a profile shape into a full face. Aim to make your cut down the middle.

These are tricky so experiment with different images. Half closing your eyes can help make it more convincing.

Yorkshire lass
(photographs, glue)

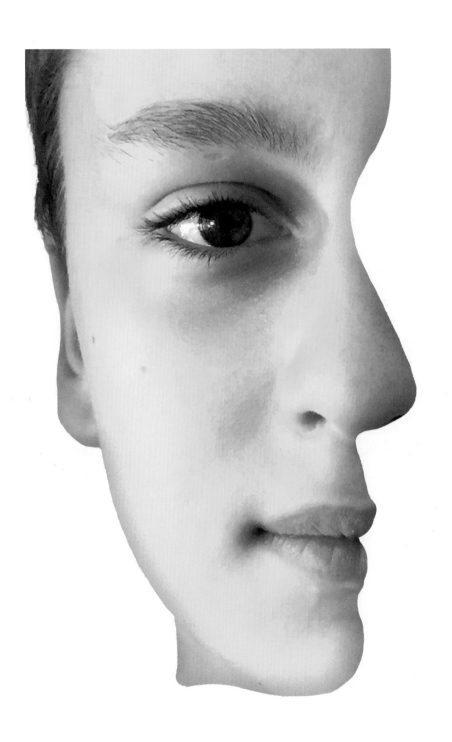

two face
(photograph, white card, glue)

#15. plastic fantastic

Brief:
Who would have thought a few plastic disposables could
be so attractive? Plastic is abundant and makes a great
source of material for artists - from multicoloured cutlery,
graphic bottle tops, plant pots, old credit cards, buttons,
hair combs, clothes pegs to most things you'd find in the
hardware shop such as cable ties and screw plugs.

We are looking to <u>create textured 2D and structured 3D
artworks using multiple plastic objects</u>. Using similar
objects, for example all cutlery or bottle tops, start
to arrange them in a regimented pattern. Forks and spoons
make a good combination because they have contrasting
features: spiky prongs and curved dish shapes. The
implements are carefully chosen for colour and distributed
to give a striking and balanced composition. The strong
background colour clearly defines the shapes made by the
arrangement. The forks and spoons thread underneath
and above each other, taking different directions,
and there's a mix of sizes and styles.

"I FOUND I COULD
SAY THINGS WITH
COLOUR AND SHAPES
THAT I COULDN'T
SAY ANY OTHER WAY
- THINGS I HAD NO
WORDS FOR."
Georgia O'Keeffe

opposite: plastic fantastic
(plastic spoons and forks,
coloured paper)

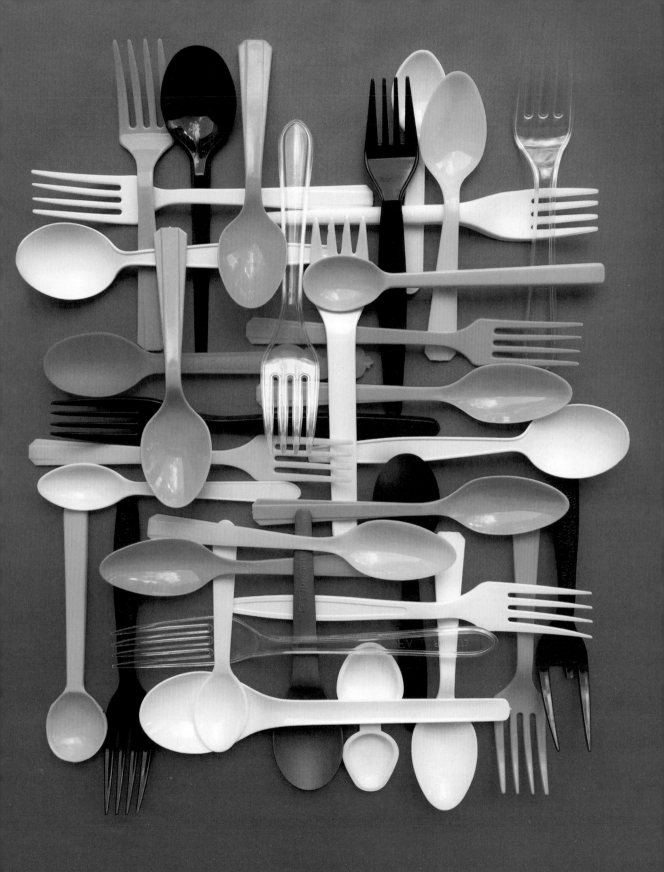

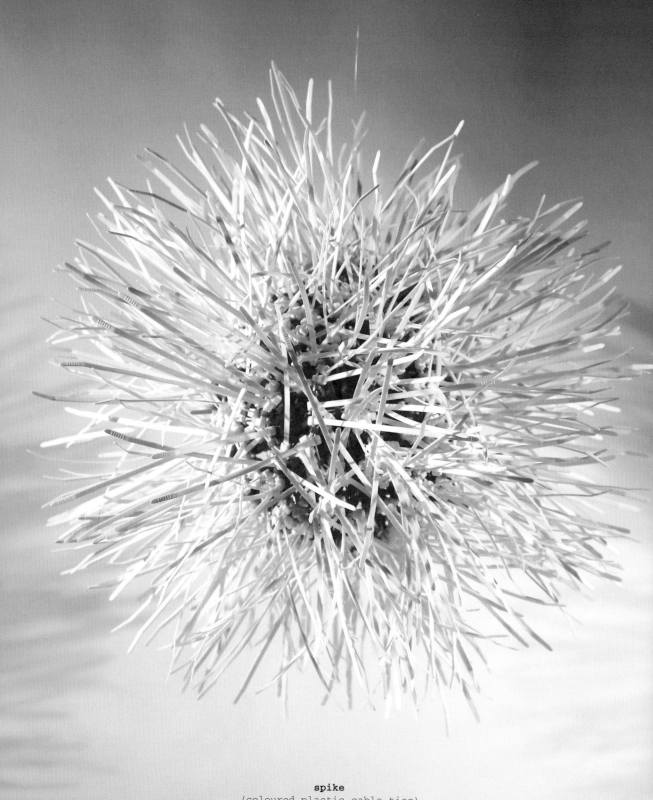

spike
(coloured plastic cable ties)

1.

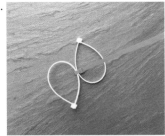

A striking 3D structure can be made from blue and white plastic cable ties.

1. Looped white cable ties are linked together using blue cable ties. Leave the blue ties full length once they are secured.

2. Construct lines of linked loops.

3. With a plastic ball as a template, start by running a line of links in a ring around the ball, then add another ring in the opposite direction to form a cross and secure. It will start to form a net-like construction around the circumference.

4. Then fill in the gaps with more loops.

5. Finally add more white ties, leaving the lengths to poke outwards.

6. The ball can then be punctured and removed. Push the blue lengths of the ties inside the white sphere. The white lengths are left poking outwards.

7./Main image. Hang with fishing wire attached to the centre and photograph.

2.

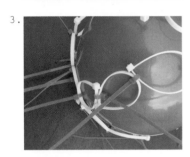

3.

4.

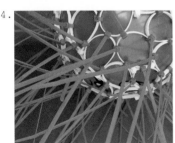

5.

#16. the dot

Brief:

An alternative to drawing – <u>create delicate images by punching holes into paper</u>. Explore the process to make or develop an image. You can transfer as much or as little detail as you wish, giving quite different effects. Highlight the design by shining daylight or artificial light through the holes. Stick your design to a window or lightbox, then photograph.

1.

1. Draw the image you will base your dot design on. Photocopy it, and secure it to a sheet of paper with masking tape. Use a sharp pointed tool or thick needle to punch tiny dots – as many or few as you like – to trace the design.

2.

2. Once you've completed your design, remove the photocopy to reveal a dotted version of the original image.

3. The finished piece can be viewed from either side of the paper depending on which complements your artwork. This image at left reveals the side with the raised dots, whereas opposite, the smooth indented dots suit the grey paper and let the light from the window come through.

3.

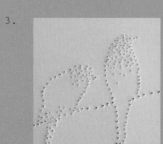

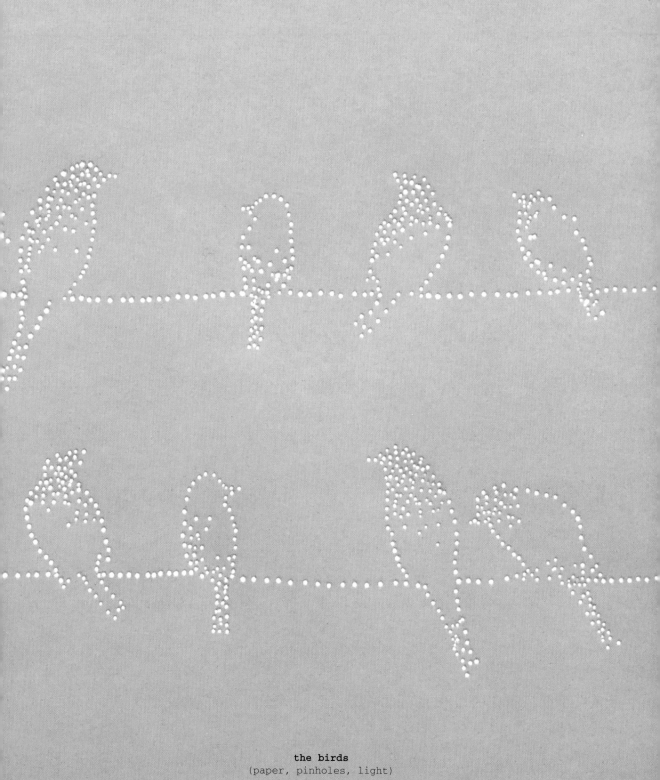

the birds
(paper, pinholes, light)

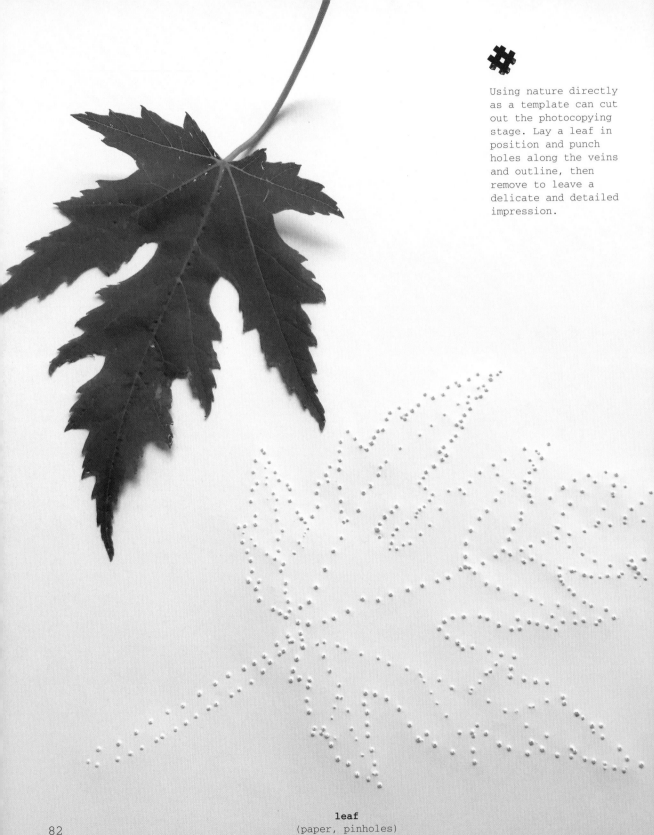

Using nature directly as a template can cut out the photocopying stage. Lay a leaf in position and punch holes along the veins and outline, then remove to leave a delicate and detailed impression.

leaf
(paper, pinholes)

The same technique,
but adding coloured
embroidery thread
through the existing
holes can simulate
water or whichever
effect you like.

Use a large-eyed
needle to add
coloured thread
to your image.

riverside
(paper, pinholes, cotton)

#17. playing with pattern

<u>Brief:</u>
This project invites you to play with pattern and create your own designs using a variety of different mediums to <u>explore shapes, space and colour combinations.</u>

Many artists use pattern in their art: yhink of Damien Hirst's famous spot paintings and repeat butterfly wings, Yayoi Kusama with her psychedelic polka dots, Sarah Morris's architectural influence, and Anni Albers with her geometric textile designs.

There are two art directions to take: <u>architecture and nature.</u> Research with your camera. Hit the streets looking for geometric shapes in buildings, floors and surfaces. Explore the countryside, the park or your garden and be inspired. Get up close and look for pattern details. Collect imagery on which to base your design. Emulate the shapes and patterns you see.

"CREATIVENESS IS FINDING PATTERNS WHERE NONE EXIST."
Thomas M. Disch

opposite: dot
(coloured paper, pen)

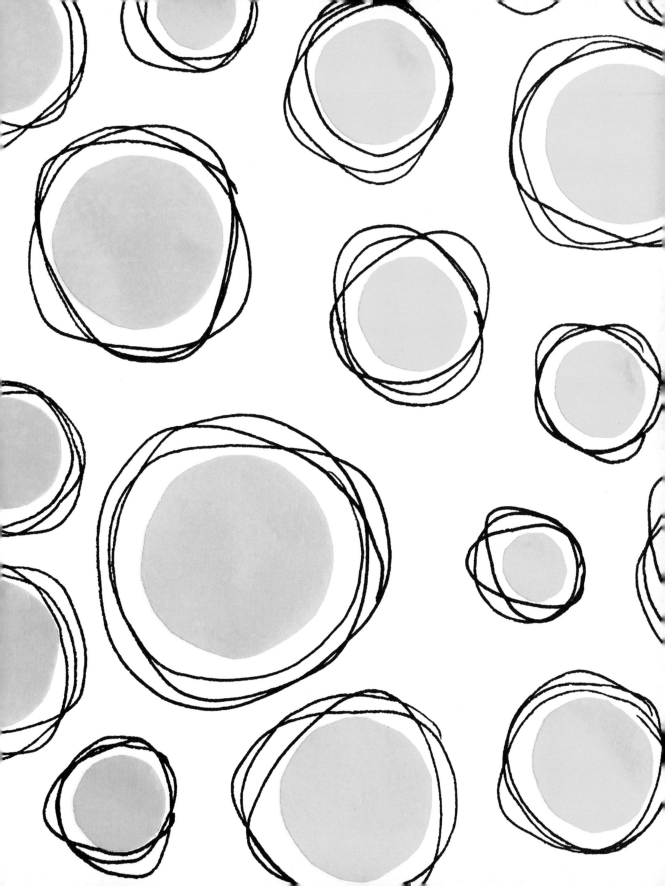

<u>Pattern inspired
by architecture</u>.

Design your own
patterns from your
research. Here are
some ideas to get
you started.

1. Felt-tip pen
 parallel lines.

2. Flat colour paper
 shapes.

3. Cut paper shapes
 with felt-tip pen
 and paint details.

4. Black card cut-
 outs on white
 paper.

5. Pen and black ink
 on white paper.

6. Black paint
 printed using the
 end of a matchbox.

1.

2.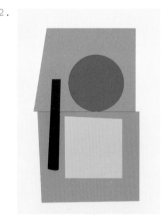

3.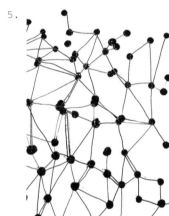

4.

5.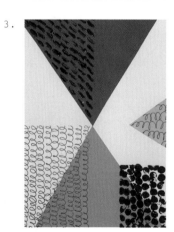

6.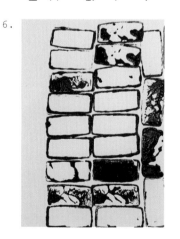

<u>Pattern inspired
by nature</u>.

1. Tissue paper
 layers.

2. Cut-out white
 paper leaves on
 green paper.

3. Overlapping shapes
 in coloured PVC
 sheets and card.

4. Cardboard tube
 with one end
 dipped in white
 paint and printed
 onto black paper.

5. Coloured paint
 dragged onto paper
 with a card edge.

6. Cotton wool buds
 printing black
 acrylic paint
 on paper.

1.

4.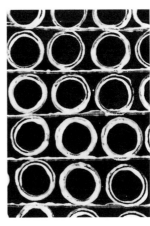

2.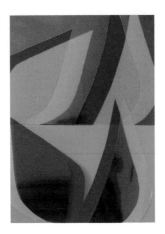

5.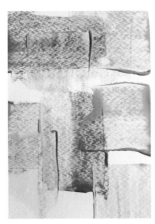

3.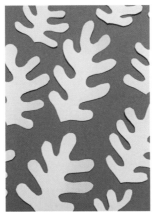

6.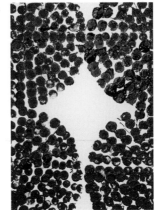

#18. in the shadows

Brief:
This is a photography challenge! Get your camera out – a phone camera will do – and be on the lookout for fascinating shadows. You can find them anywhere, or create your own. All you need is some sunshine!

Shadows distort reality by reproducing the original form they're cast by in a different perspective. Move quickly as they are temporary and unique from moment to moment. They vary with light intensity: strong bold shapes in bright, direct sunlight can become soft, delicate and mysterious on a cloudy day. How will you crop your image? Look at the image and see if you can make it stronger by cropping it. Does one section become something else when you crop it? Think about the surfaces where the shadows fall – they will add to the photo. Grainy concrete, geometric bricks, dusty pavements... they all become the canvas to the images. Have fun and collect as many images as possible on your travels, then edit them down to 25 of the best. Choose contrasting viewpoints, colours and compositions then display them together as a set.

"THE SHADOWS ARE AS IMPORTANT AS THE LIGHT."
Charlotte Brontë

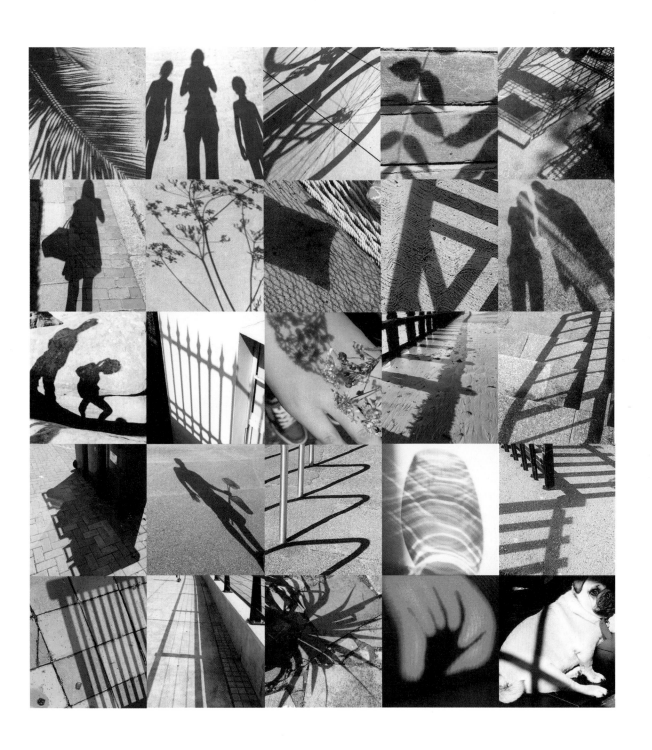

shadows by texty girl
(phone camera)

#19. it's a small world

Brief:

Create your own miniature installations. Get out your
old toys or find mini figures in haberdashery shops or on
the internet, and look for an environment in which to
place them. Think about composition. Think about scale.
Scout your cupboards for everyday objects and create an
environment for your little people. Keep them within
their natural environment so that the object can still
be identified. Make clever connections as you combine
your backdrop with your figures. Look for the unusual
in the ordinary.

Build a world where shoelaces become snakes, wander
through forests of broccoli, ride banana-skin slides,
float on cotton wool clouds, and trek through grass
that becomes a jungle, or sandpaper beaches...

A phone can conjure up endless backgrounds
for your little people to explore...

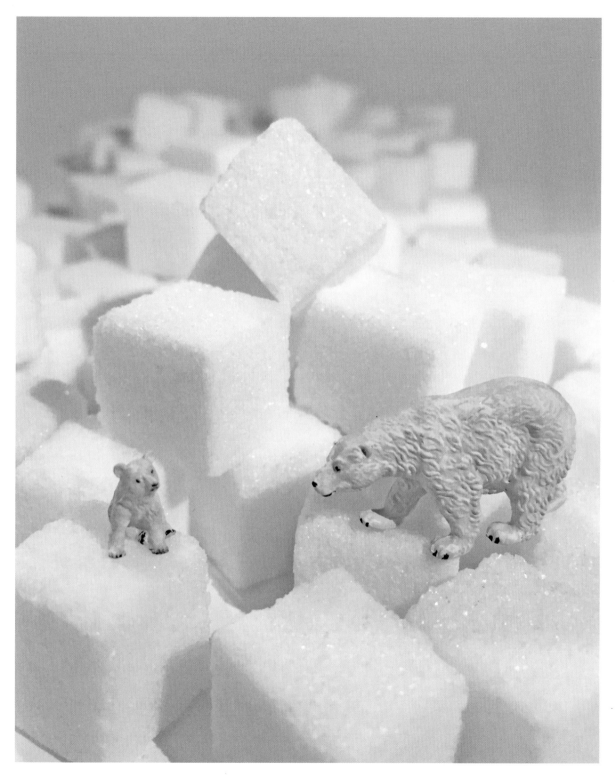

icebergs
(sugar cubes, plastic figures)

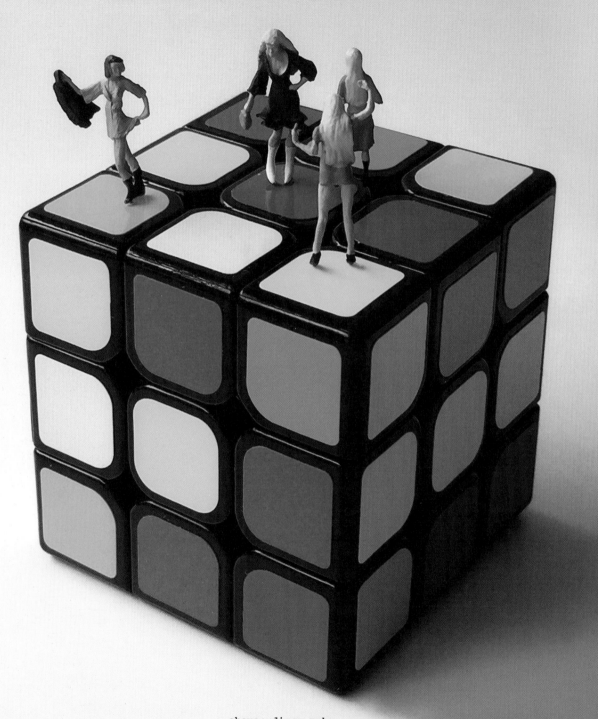

above: disco cube
opposite: iPond
(model figures, Rubik's cube, mobile phone)

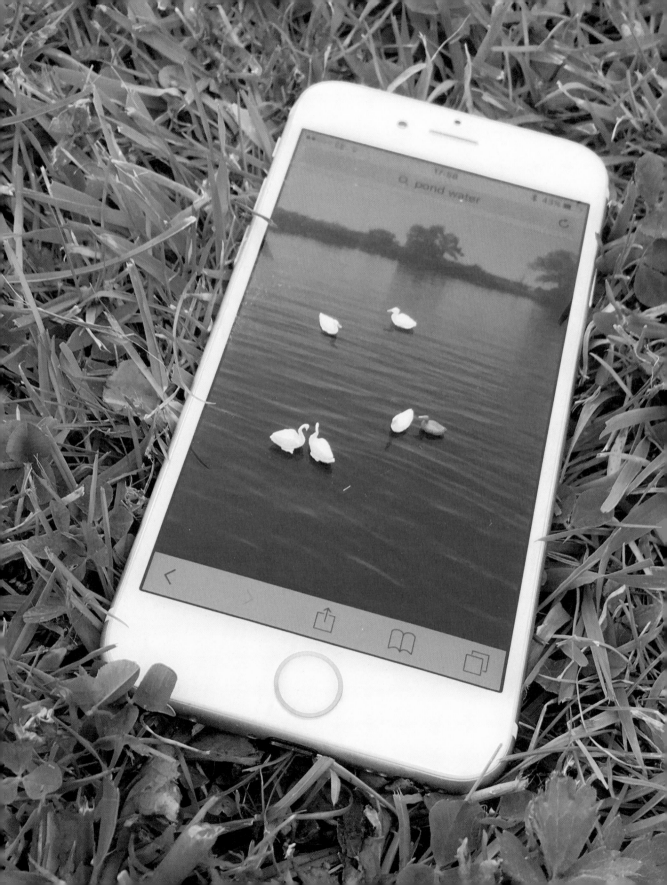

#20. air art

<u>Brief:</u>

Distort the world around you by adding the unexpected to everyday situations. We've all seen photos with the Eiffel Tower balancing on the palm of a hand... well the principle of this project is the same, but stretches the imagination with carefully selected and prepared props.

This project encourages you to <u>consider proportion and perspective by experimenting with background and foreground</u>. There are two parts: creating a visual prop and selecting a backdrop. The two elements should work together to tell a story or express an idea, which is captured with a camera.

Search for images in old books, magazines, photographs, etc., looking for people or objects – or draw and paint your own. These will be your props. Images should be no bigger than the palm of your hand. Carefully cut them out and mount them onto card. Hold them up against your chosen background; you may have to experiment with the distance at which you hold them to make the proportions look right. Capturing the scene with your camera flattens it to a striking and unusual image!

"I WAS ALWAYS INTERESTED IN PHOTOGRAPHY BECAUSE IT MAKES A PICTURE."
David Hockney

opposite: oh no!
(card, photocopy, camera, model)

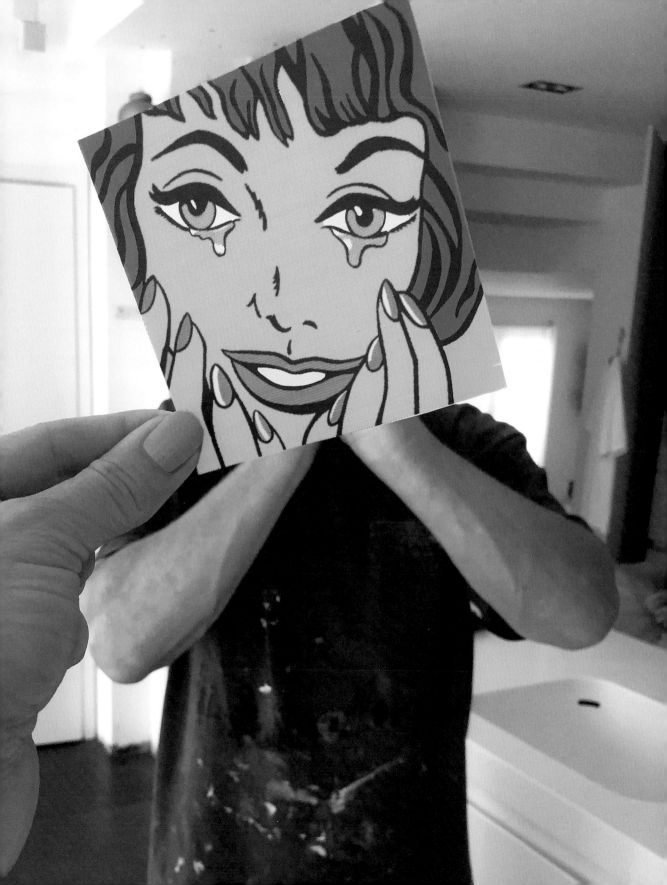

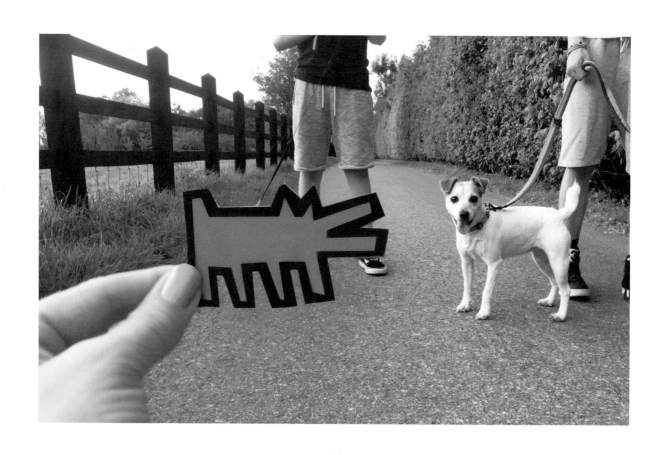

woof
(card, photocopy, camera, models)

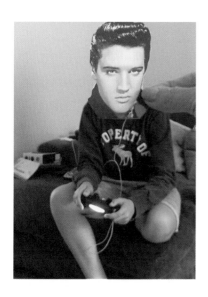

Using some of the cut-out image props to the right, here are some photo ideas for inspiration.

Elvis is in the house and there's a tiger in the garden!

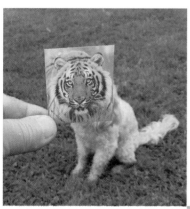

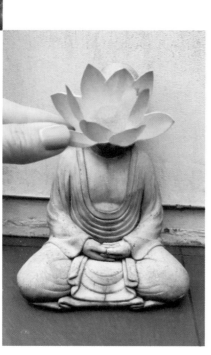

Buddha statue with lotus flower.

#21. sticky-note art

Brief:

Fine-art pieces made with sticky notes! Using sticky notes in a variety of colours and sizes, experiment with different techniques: try making <u>flat, pixelated images</u> applied directly to a surface, where walls, windows, doors, floors and ceilings make great canvases for artworks; <u>folded 3D constructions</u> fixed to a surface with different folding techniques, producing protruding shapes and textures; or <u>freestanding abstract sculpture</u> where constructed layers can be built and stacked.

Flat pixel images:

First, decide on your image, pattern or shape. If it's a complex design, you can work it out on squared paper beforehand to use as a guide, the square format dictating the pixelated images you create. Carefully select your colour palette from neon to pastel shades, plus black and white, ensuring you get enough contrast between each square to define your image. Apply your notes directly to a surface.

You could create a simple animation by taking a series of photos as you slightly change the position of your character/pattern/scene. Keep the camera steady and in the same position for all the shots (use a tripod if you can). Put the images together using an app, computer program or internet animation creator - or simply print out your photos in a small format and collate them together to make a flip book, fixing them with a bulldog clip.

"IT'S ALWAYS THE SMALL PIECES THAT MAKE THE BIG PICTURE."

unknown

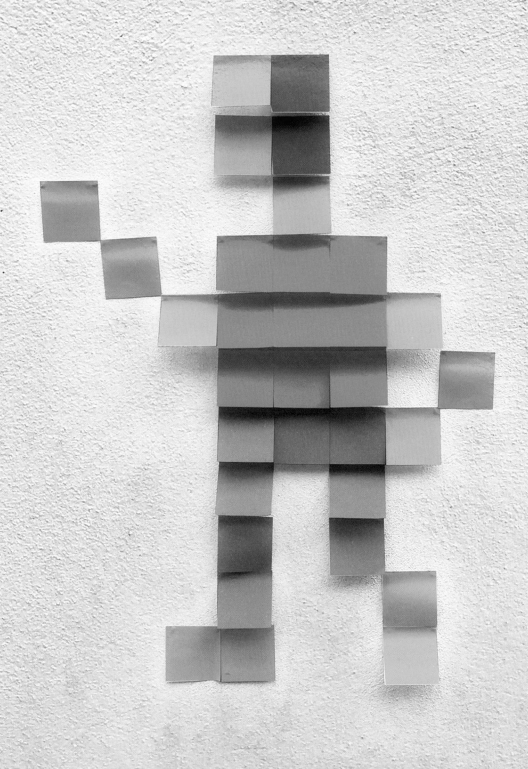

little man
(sticky notes)

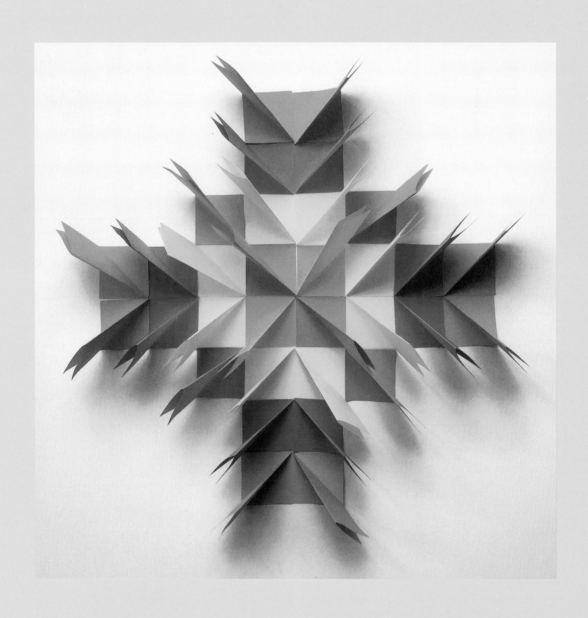

winged cross
(sticky notes, card)

Different ways to fold a sticky note.

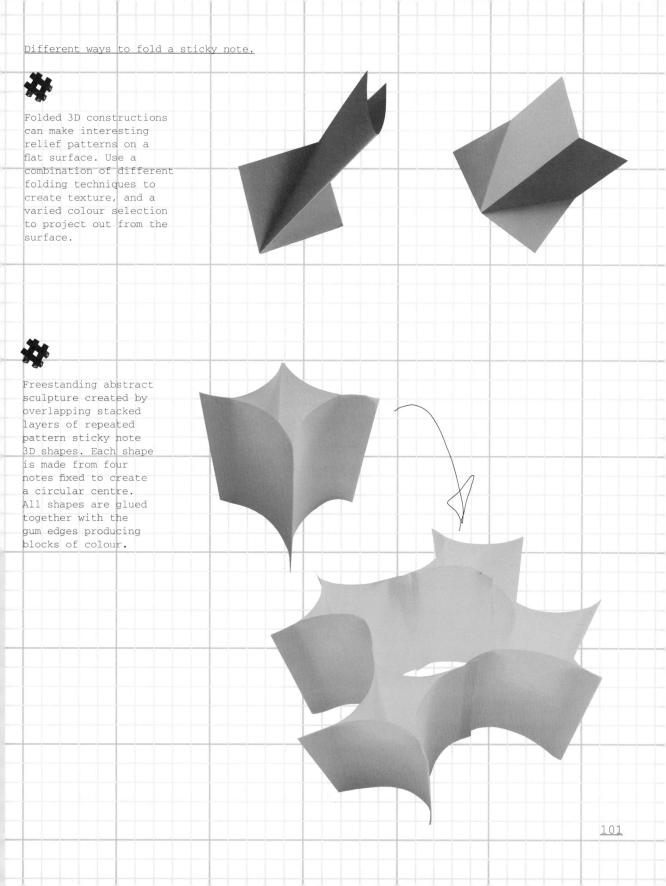

Folded 3D constructions
can make interesting
relief patterns on a
flat surface. Use a
combination of different
folding techniques to
create texture, and a
varied colour selection
to project out from the
surface.

Freestanding abstract
sculpture created by
overlapping stacked
layers of repeated
pattern sticky note
3D shapes. Each shape
is made from four
notes fixed to create
a circular centre.
All shapes are glued
together with the
gum edges producing
blocks of colour.

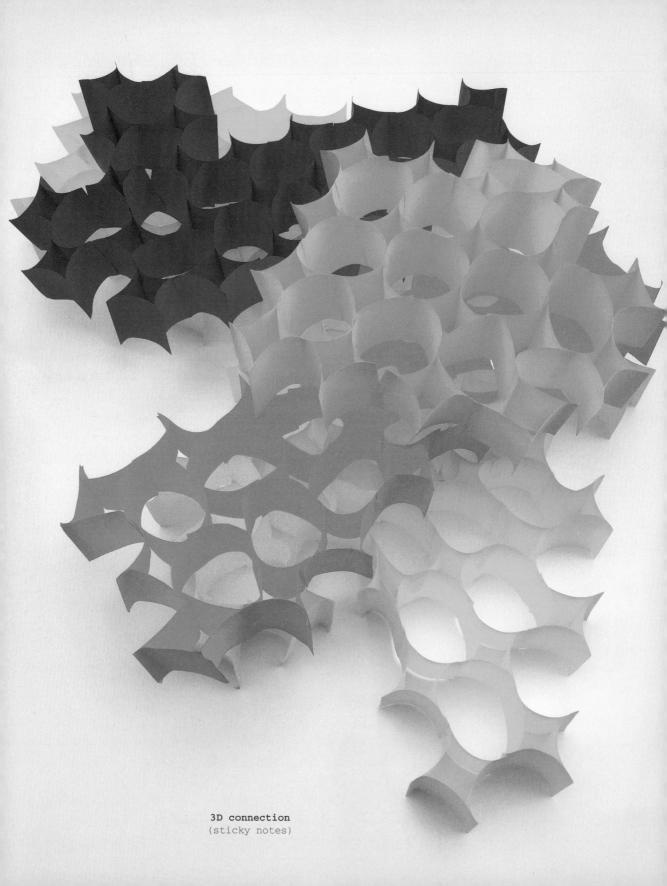

3D connection
(sticky notes)

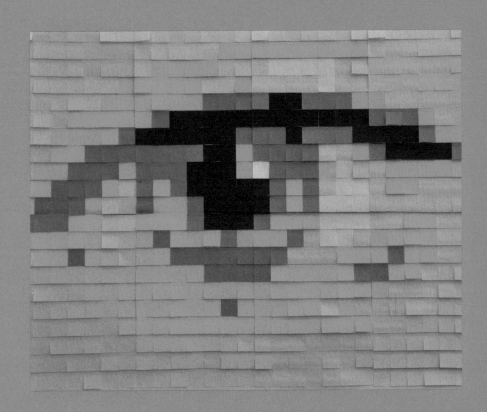

wink
(sticky notes)

#22. shape shifters

Brief:
Begin by creating shapes and exploring mark-making using
as many different implements and materials as you can find:
anything from cotton wool buds and bottle tops to polystyrene
packaging shapes, leaves, shapes cut out of plastic, orange
peel, potatoes...

Create your tools to print from. Experiment with paints
and inks to transfer the shapes onto a variety of surfaces.
Consider colour combinations and textures; try under- and
overloading your tool with paint. Each print will give a
different impression; even using the original shape over
and over again will give a unique mark every time.

Think carefully about how the individual shapes sit with
each other; large shapes can complement a busy block of
detailed dots, and outline shapes work with solid colours.

To get you started, here are some examples of random shape
patterns created by simple block-printing (pages 105 and
107) and stencil cuts (page 106).

The pattern
formation
opposite
uses cut
foam shapes,
circular
pieces of foam
attached to
the end of a stick
and cotton buds
loaded with
paint. Detail
was added to
some of the
shapes using
a black felt-
tip pen.

left: Shapes
cut from sheets
of polystyrene
foam with a
handle made
from masking
tape.

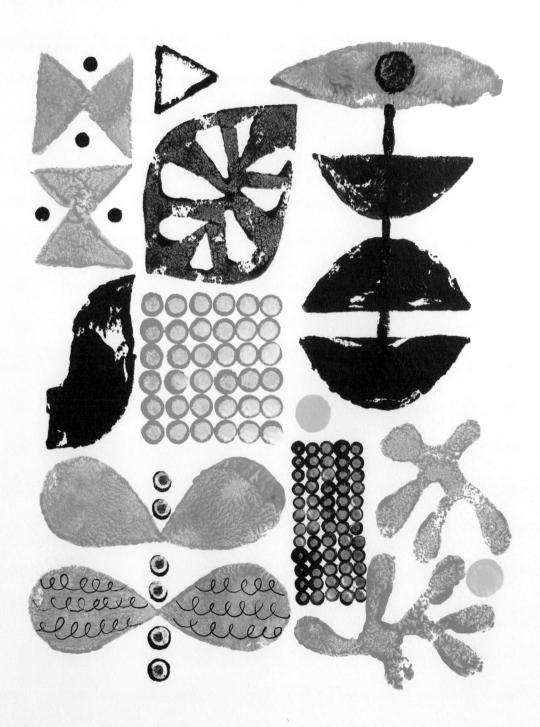

shape shifter
(cut foam shapes, cotton buds, paint)

Each shape is an individual stencil cut from white card. The shapes are positioned randomly to form a bold geometric pattern. Limiting a design to just one colour allows focus on the shapes and spaces.

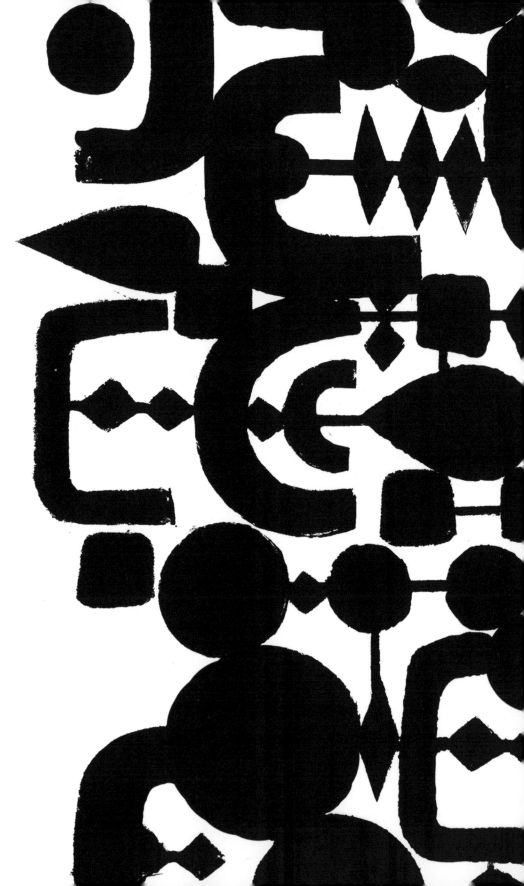

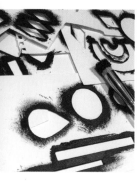

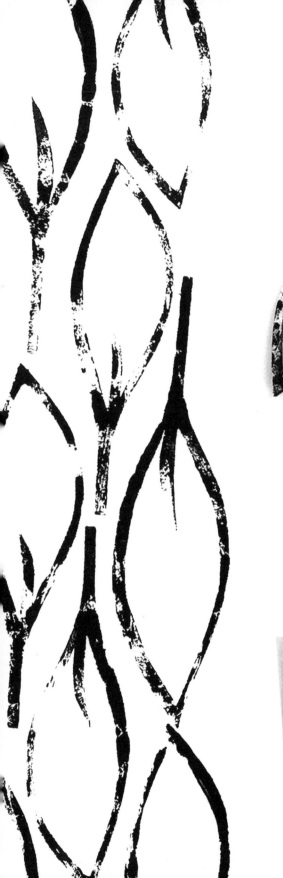

Left: Simple shapes cut from a polystyrene sheet, with a handle made from folded masking tape, is all you need to start printing.

Vary your print surfaces: paper, wood, fabric, plastic, etc. Simple objects can be used to make your marks; for example, the edge of a credit card gives a feathering drag paint line, cotton buds are great for repeat patterns, and fine ink pens can add detail to a block of colour.

Below: Balsa wood strips with paint and ink.

#23. scribble

Brief:
There's a unique quality in a scribble drawing: the spontaneity of the line, the ability to build shade, shadow and definition by loosely repeated, quick strokes. Artists such as Andy Warhol and Picasso experimented with pen sketches; today, the trend is growing and a number of artists are using ballpoint pens to produce gallery-quality artwork.

Start with a simple outline to define your shape, then begin to build detail. Work quickly and freely. Regularly pause and look at your piece from a distance to ensure you don't overwork the image. You can build the texture and gradually create depth. Try using a continuous line, not taking your pen off the paper, and creating curved strokes.

Vary your style: mix tight and erratic strokes, work with different thicknesses of line, from bold to fine, and combine small and large loops.

"A drawing is simply a line going for a walk."
Paul Klee

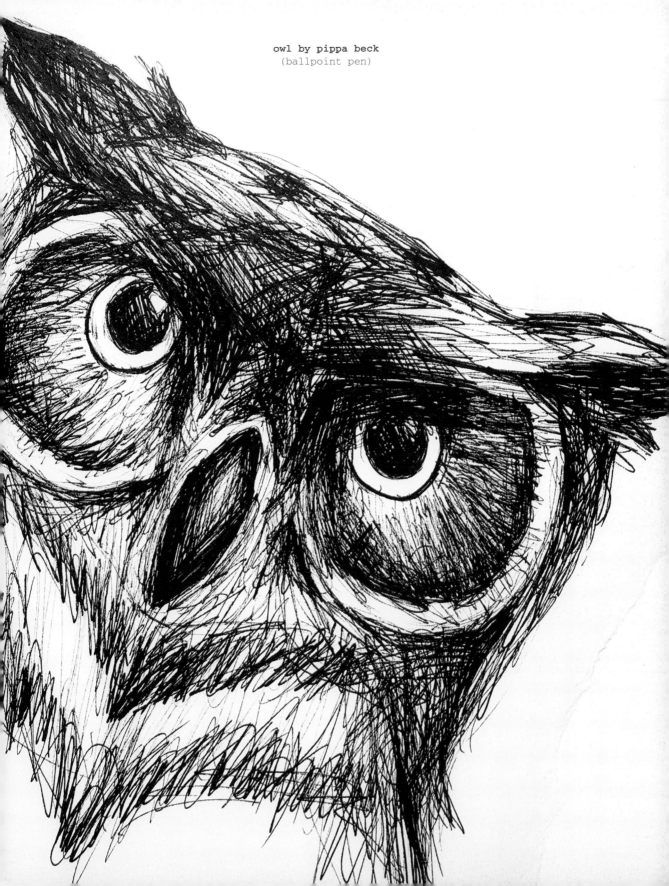

owl by pippa beck
(ballpoint pen)

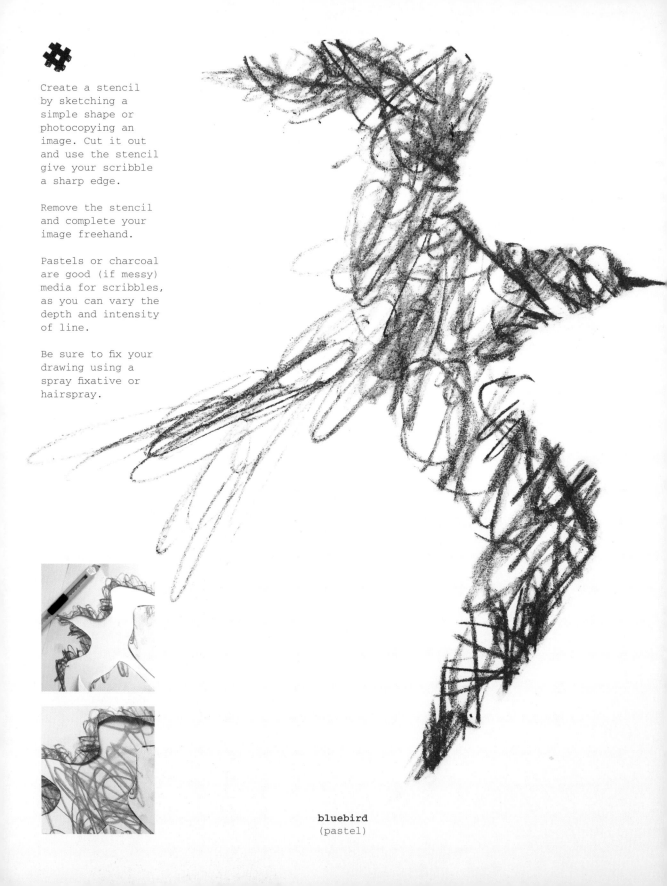

Create a stencil
by sketching a
simple shape or
photocopying an
image. Cut it out
and use the stencil
give your scribble
a sharp edge.

Remove the stencil
and complete your
image freehand.

Pastels or charcoal
are good (if messy)
media for scribbles,
as you can vary the
depth and intensity
of line.

Be sure to fix your
drawing using a
spray fixative or
hairspray.

bluebird
(pastel)

sadness
(paint on dry brush)

A loaded brush used
continuously will
start to dry out
and produce some
fantastic marks.

Make a stencil, as
shown opposite, to
define the outline,
then scribble within
the shape. A quick
flourish with a dry
brush layering the
texture to create
lighter and heavier
areas will complete
the image.

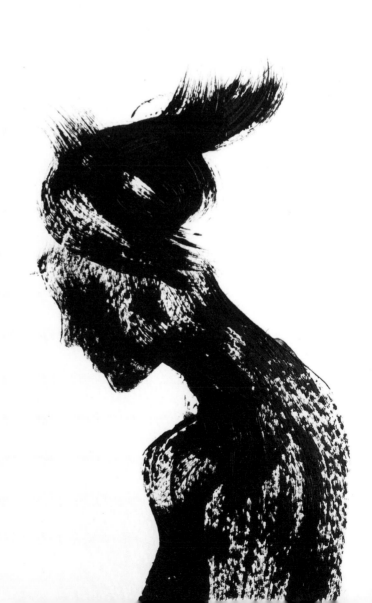

#24. repeat repeat

Brief:

Many artists are collectors and this is often reflected in their work. Pop artist Peter Blake takes inspiration from his collections. An avid collector since childhood, his obsessions include shell boxes and other things decorated with shells, troupes of toy elephants, art curios, taxidermy and memorabilia.

Illustrator Ian Wright creates pixel-based artwork using collections of all kinds of different materials including lipstick cases, metal badges and postage stamps.

Generally speaking, everything repeated en masse looks fabulous. The impact of a regimented group of objects in repetitive form can be surprisingly effective.

This project involves collecting and curating similar objects to form a new and exciting artwork, whether it be a sculpture, a photograph or a permanent 2D arrangement.

"THE ARTIST IS A COLLECTOR OF THINGS IMAGINARY OR REAL."

Paul Rand

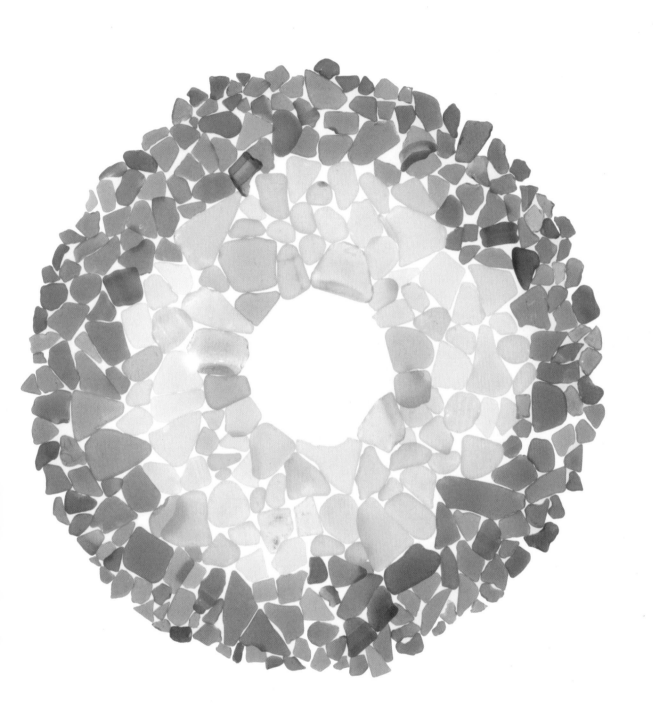

archie's sea glass
(sea glass, lightbox)

Collect everyday objects:
sea glass from the beach,
colourful plastic bottle
tops, golden drawing pins,
matchboxes, shells, rubber
bands, leaves, colourful
golf tees...

The challenge is what you
do with them to create
something new. How will
you transform them into
a display? Here are some
ideas to inspire you...

Below: A chaotic collection
of plastic babies created
using a hot glue gun and a
spherical polystyrene base.

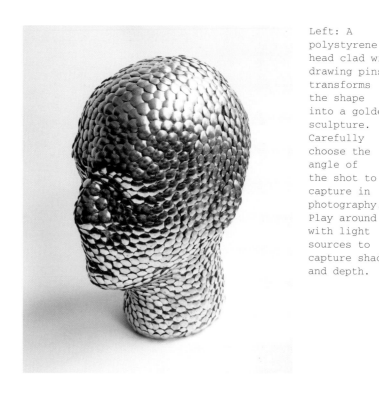

Left: A
polystyrene
head clad with
drawing pins
transforms
the shape
into a golden
sculpture.
Carefully
choose the
angle of
the shot to
capture in
photography.
Play around
with light
sources to
capture shade
and depth.

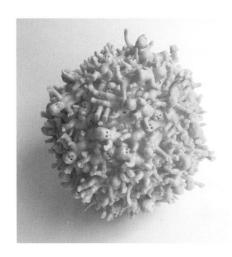

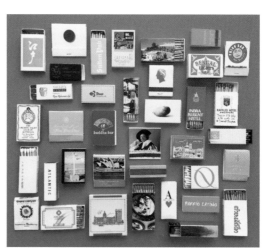

Right: A colourful collection
of matchboxes from around
the world, simply arranged
on a colour background and
photographed. The positioning,
the background and the colour
balance of the boxes all
contribute to the outcome.
Also look at the spaces in
between the objects. Let the
objects dictate the outcome.

Opposite:
Decorate your
collection
before you
arrange it.
A collection
of wooden
clothes pegs,
decorated and
arranged.

114

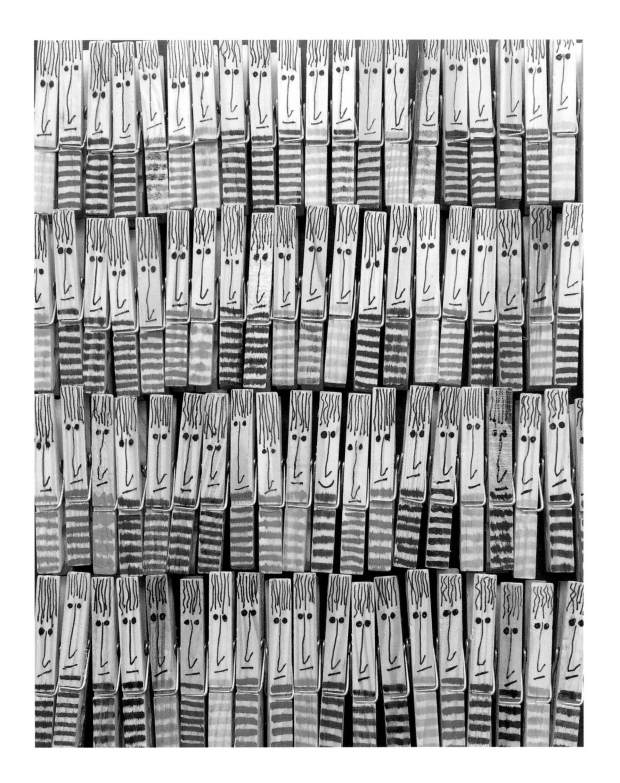

smile
(wooden clothes pegs, felt-tip pens)

#25. distorted landscapes

Brief:

How many ways can you explore a landscape? With subtle
alterations you can transform a simple landscape image
into something much more interesting...

Create surreal landscapes by combining strips of collected
outdoor images. Look for contrasting textures, colours and
forms. Using photos or found images, build exaggerated land
formations. The collage opposite was inspired by a trip through
Death Valley in the USA a few years ago, where I saw the
amazing rock formation known as Artist's Palette.

Alternatively, patchwork together a landscape from similar
pieces with contrasting colours (page 118) or combine your
landscape with a geometric shape by slicing and flipping
copies of the image to fit within a template (page 119).

"AN ARTIST IS
AN EXPLORER."

Henri Matisse

artist's palette
(magazines, photocopies, glue)

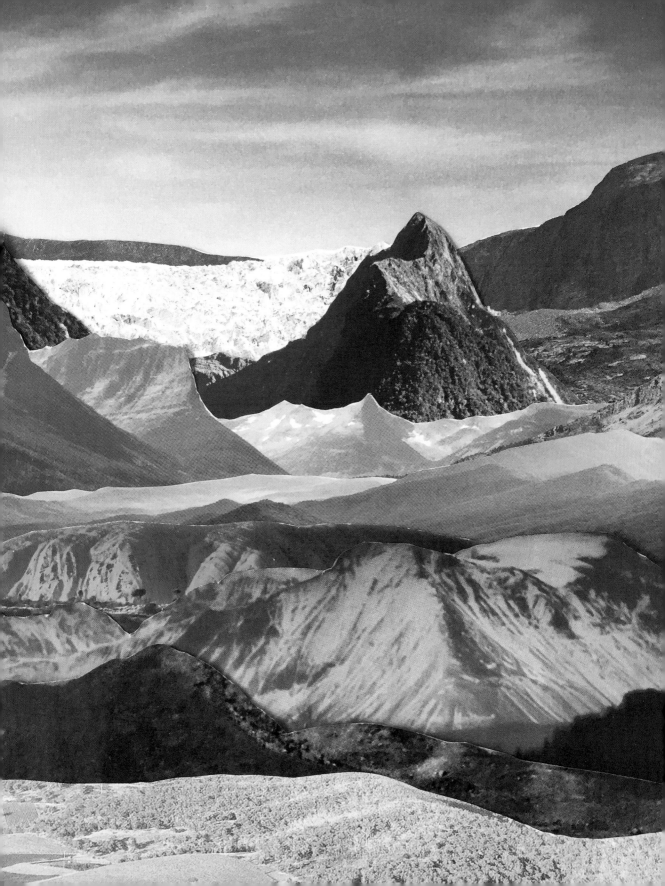

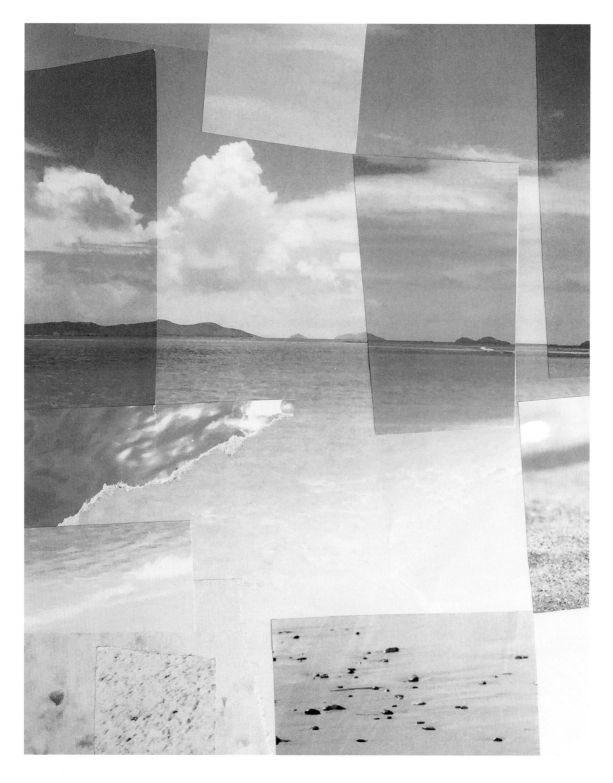

palm island
(magazines, photocopies, glue)

Opposite: Make a patchwork collage from a base image mixed with images of similar subject or colour. Build, fit and layer new pieces on top of the base. Try to replace sections with similar content but different tones and texture to reflect the composition. The image will become a jigsaw of layers. Use a photocopier or computer software to make colour changes; enlarge and reduce sections. Try adding colour to black-and-white images, or vice versa.

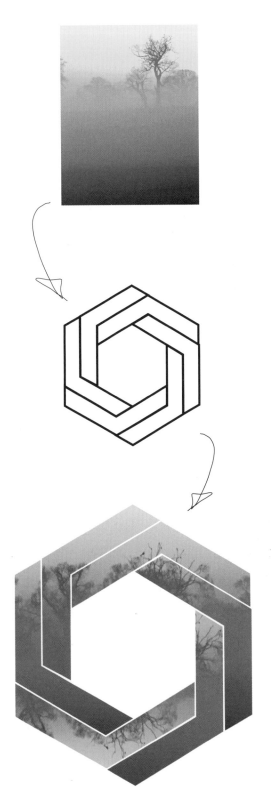

Right: Combine your landscape with a geometric shape. Start by choosing a photo. Make a template by drawing out your shape on tracing paper or enlarge one of the templates opposite on a photocopier. Place the template over a print of your image and hold in place with masking tape. Cut the shapes out of the photograph. Experiment with sections from photocopies, or limit yourself to one image.

Here are some templates to enlarge on a photocopier and use to make geometric collages.

119

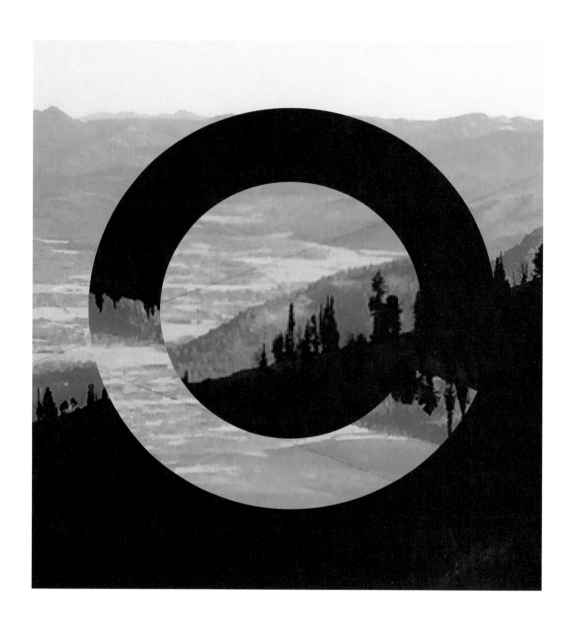

jackson hole
(photocopies, glue)

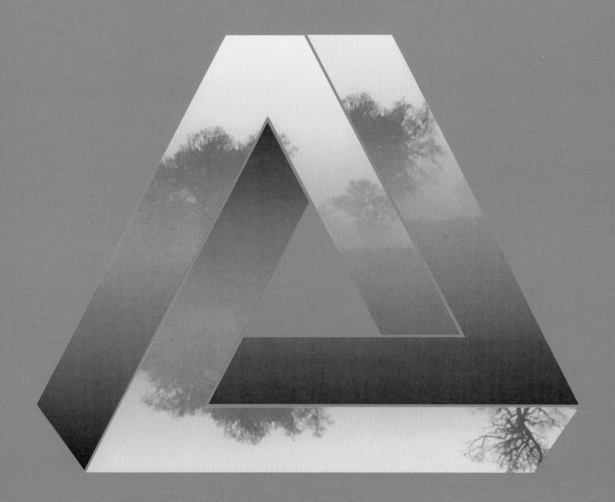

impossible triangle
(photocopies, glue)

#26. round in circles

Brief:
This is a photography challenge! Get out your camera and
be on the lookout for circles. Go beyond the obvious and
search for an unusual mix. Look for details - maybe there's
a circle hidden within an object, or perhaps you'll spot
patterns and colours that form a circle.

Search nature for a spiral; the fruit-and-veg counter at
the supermarket for a perfect sphere; or snap an illuminated
circle at the traffic lights, in three different colours!
Pavements, buildings, road signs - start looking and you'll
soon be finding circles everywhere!

Consider the background to your circle and how you might
frame it. Think about how you crop the image: get close,
discarding the bigger picture to capture a detail and
emphasize the shape.

Display your images
together within a
structured composition
or grid. Combine and
balance the colour
combination so that
they work together
as a whole.

"THE ARTIST
SEES WHAT OTHERS
ONLY CATCH A
GLIMPSE OF."
Leonardo da Vinci

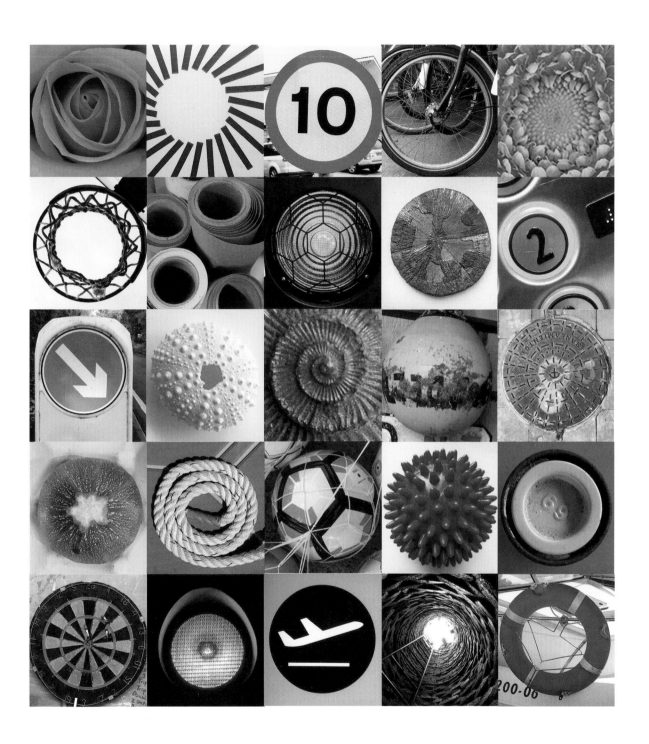

round and round
(phone camera)

#27. balsa sculpture

Brief:

Balsa is a soft wood with a fine grain. It's easy to sculpt it using a modelling knife and sandpaper. It doesn't require a special workshop; your kitchen table is fine. This lightweight wood is often used to make model aeroplanes, so is readily available to buy, and generally bought in strips which can be glued together.

Your challenge is to create a sculpture. It's best to start with a simple shape. To create the pebble sculpture opposite, for example, layers of balsa were joined together using PVA glue to form a wooden block. The combination of layers form an interesting mix of textures, depths, grain and subtle colour changes within a single shape.

Once the glue was dry, the pebble shape was marked out with a pencil, then roughly cut to the basic shape with a small saw and modelling knife (and the hole made using a small hand drill). The final shape was defined using coarse sandpaper, then refined with a fine sandpaper for a smooth surface and to enhance the grain detail.

What can you come up with?

"SCULPTURE IS THE ART OF THE HOLE AND THE LUMP."
Auguste Rodin

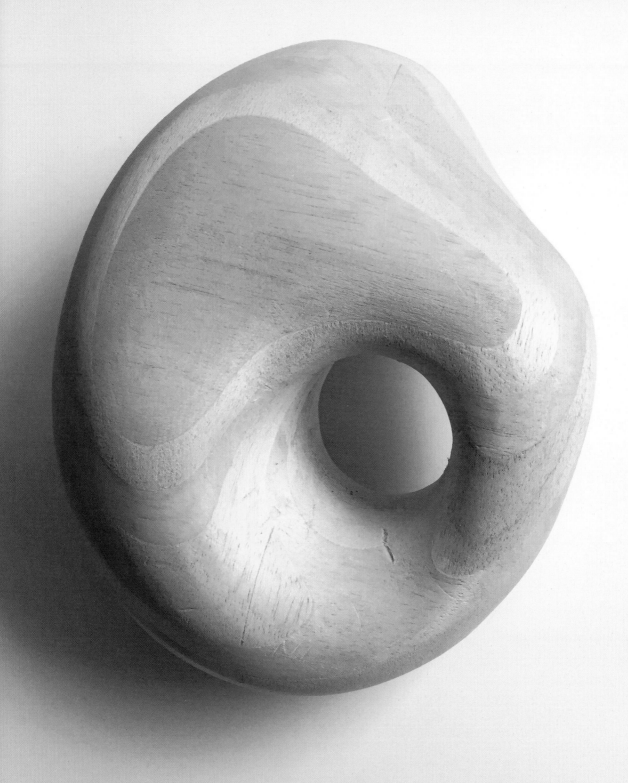

pebble with hole
(balsa, pva glue, sandpaper)

Making your balsa
sculpture.

1. Balsa can be
bought in sheets
of different
thicknesses.

2./6. Glue
pieces of balsa
together to form
a block, leaving
overnight to dry.
Stack different
thicknesses, grains
and colours to give
an interesting
layered effect.

3. Cut your block
to roughly the
right size using
a handsaw.

4. Shape your
piece Using
different grades of
sandpaper, starting
with coarse and
moving on to finer
grades as you get
closer to finishing,
to get your desired
shape. Balsa is a
soft wood so should
take shape pretty
quickly.

5./Main image.
A decorative balsa
wood pebble stack;
each decorative
pattern is made
with hot skewers,
heated up on the
hob, giving detail
ridges and charred
shapes. Be sure
to wear an oven
glove as the skewer
becomes very hot.

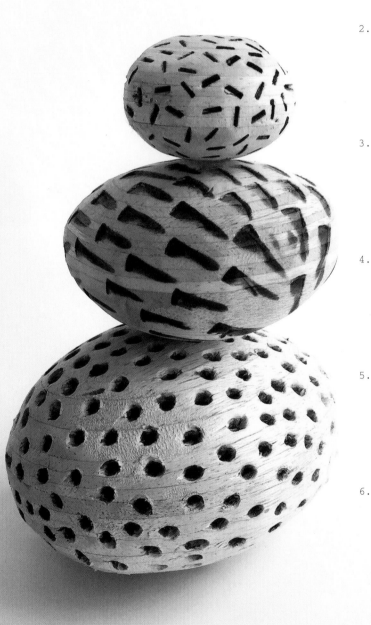

1.

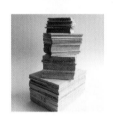

2.

3.

4.

5.

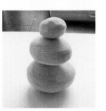

6.

pebble Stack
(balsa wood)

A simple marquetry-style
composition of balsa wood
pieced together to form a
mountain range.

First draw your design
in pencil — a template
can help you get it
right — then cut out
the shapes with a craft
knife. Paint, wash or
decorate, and then glue
together with PVA glue.

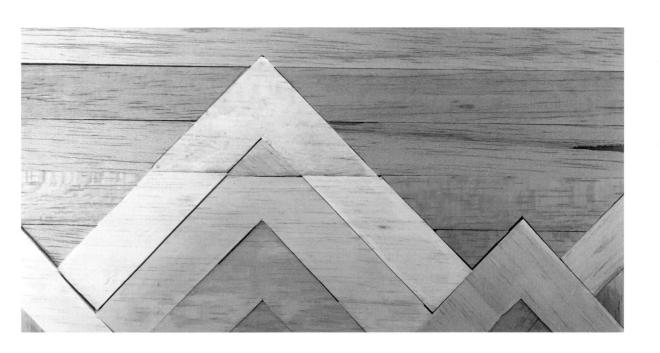

teton mountains
(balsa wood, paint)

#28. petri-dish experiments

<u>Brief:</u>
Art and science make an unusual mix. This project is inspired by microbial art, a form in which unique artworks are created using living bacteria and fungi, each organism growing differently, producing the most colourful and strange designs. Some of these experimental artworks don't appear colourful immediately but develop over time, while others have their colour almost straight away. The artists use a petri dish of agar jelly* as their canvas, and instead of using paint they use microorganisms – experimental beyond belief.

This project imitates the approach and mirrors the outcome using petri dishes, PVA glue, coloured inks or watery paints and imagination. The interesting thing is watching and capturing your inky patterns as they grow and develop over time, with your camera. It's an exciting and experimental process: <u>you control the start, but the results are unpredictable.</u>

*Agar jelly is a gelatinous-like substance used in microbiology as a growth medium to cultivate microorganisms such as bacteria and fungi so they may be observed under a microscope.

"ALL GOOD SCIENCE IS ART. AND ALL GOOD ART IS SCIENCE."
John Fowles

bacteria by alfie mcmeeking
(petri dishes, PVA glue, coloured inks)

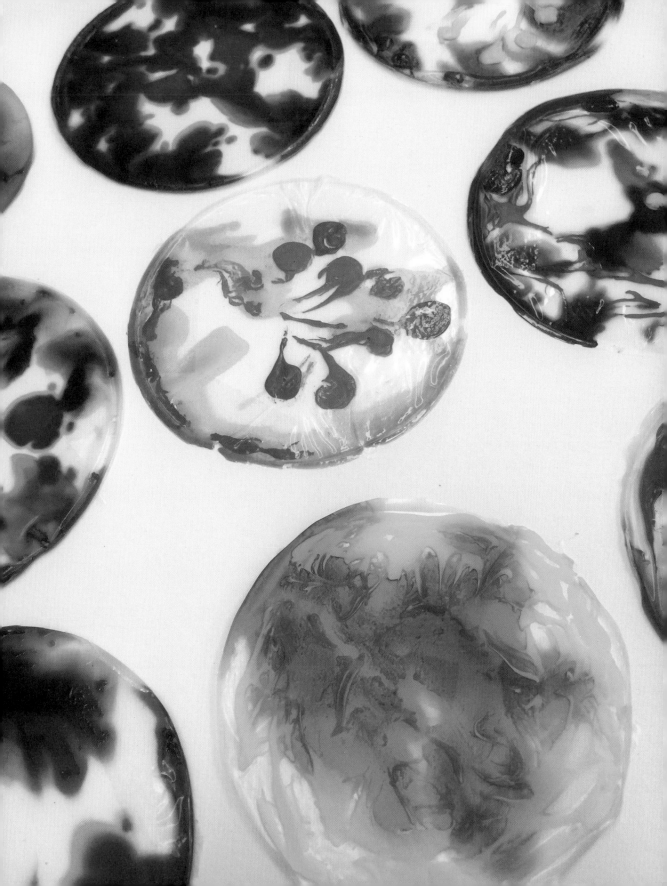

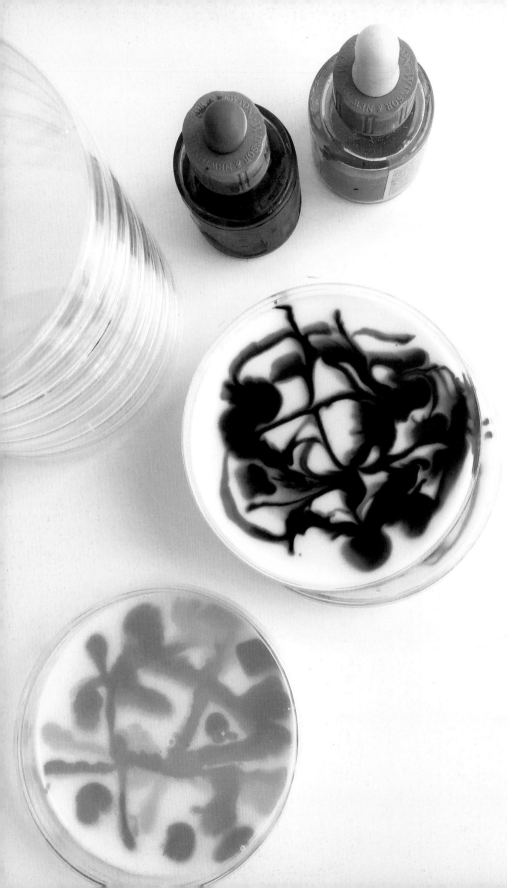

Snap on your latex gloves, grab a stack of petri dishes, some PVA glue and a variety of coloured inks. This exciting process is experimental and unpredictable, with fantastic results.

1. Start by lining your petri dish with a thin layer of PVA glue. Pour it in and let it level out.

2. Choose your coloured inks and decorate the surface of the wet glue. Experiment with drops and dribbles, and use a brush for more direct shapes. A matchstick can be used to drag the colours.

3. Leave space on your PVA canvas to give your colours a chance to grow. Your decorative patterns will develop over time so keep your camera to hand and capture the process.

4. Eventually the white glue will dry clear, probably overnight, to form a clear and solid jelly-like disc.

5. Photograph a collection of your circular creations; overlapping and precisely spaced arrangements both make an interesting final canvas. You can (carefully) remove the jelly discs or leave them in the transparent dishes.

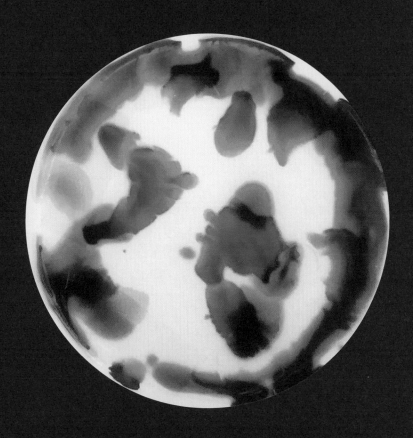

cultural by alfie mcmeeking
(petri dish, PVA glue, coloured inks)

#29. land art

<u>Brief:</u>
A great outdoors experience, land art (or earth art) is all about sculptural forms that take shape in relation to the landscape; an art movement born in the '60s and early '70s.

Land artists generally take inspiration from nature and <u>use materials from the natural world to construct geometric forms and shapes</u> to connect with a natural environment. It can be permanent or temporary.

Create your own land art: a tower of pebbles on the beach, a regimented arrangement of leaves with different colours and shapes, a frozen ice stack of captured flowers... Take a look and see what you can find to work with in the park, your garden or on a trek around the countryside.

Be inspired by land artists around the world. As a starting point, look at the amazing sculptures of British artist Andy Goldsworthy and the magical rock-balancing of Canadian-born Michael Grab.

"TO THE ARTIST THERE IS NEVER ANYTHING UGLY IN NATURE."
Auguste Rodin

holey stones
(pebbles)

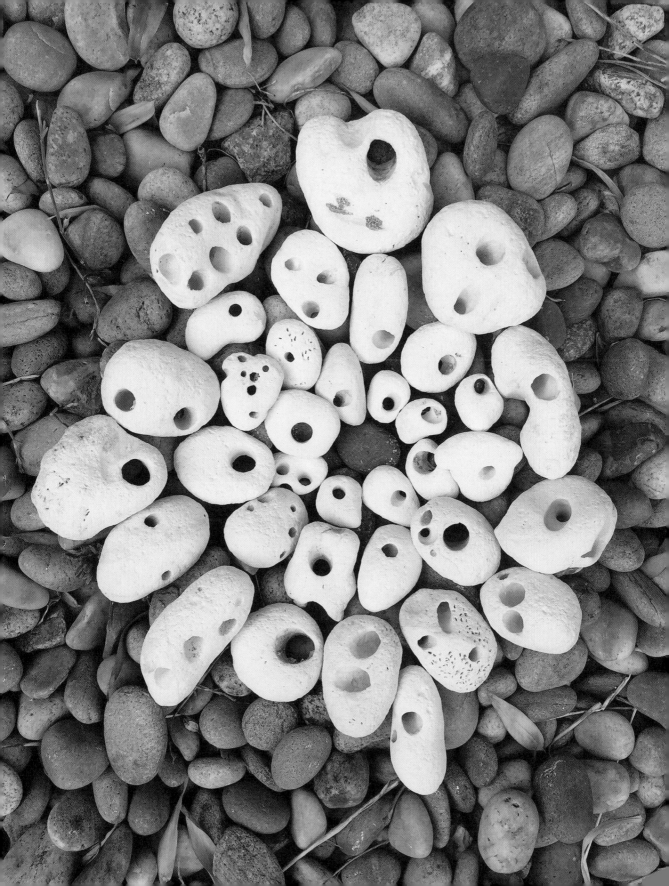

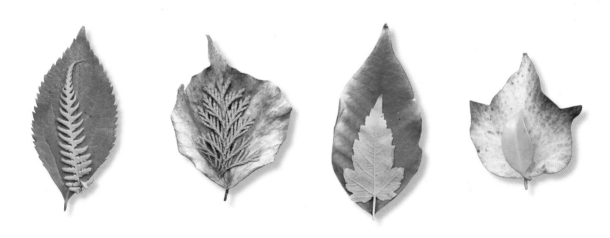

above and opposite: leafy pairs I and II
(leaves, slate)

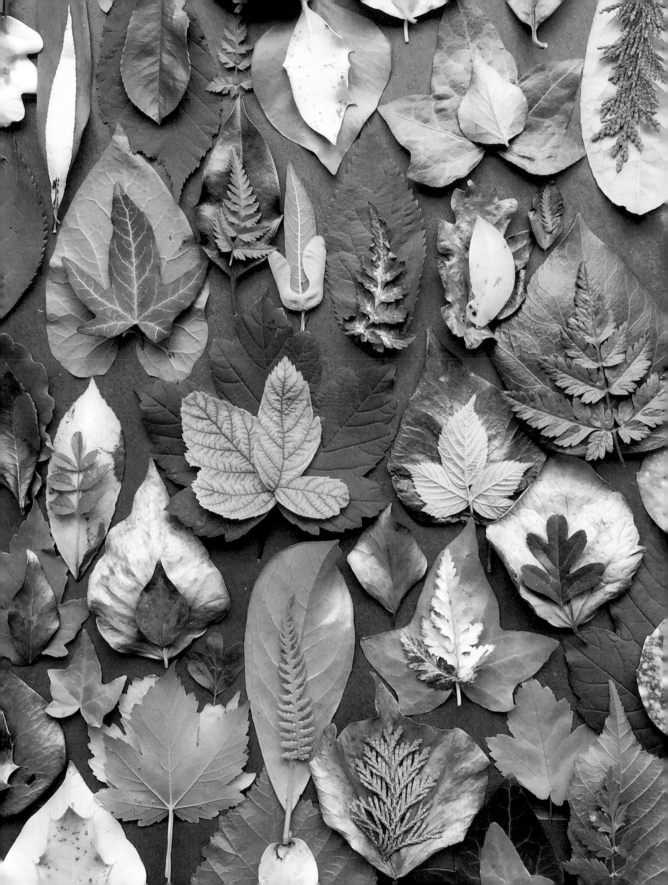

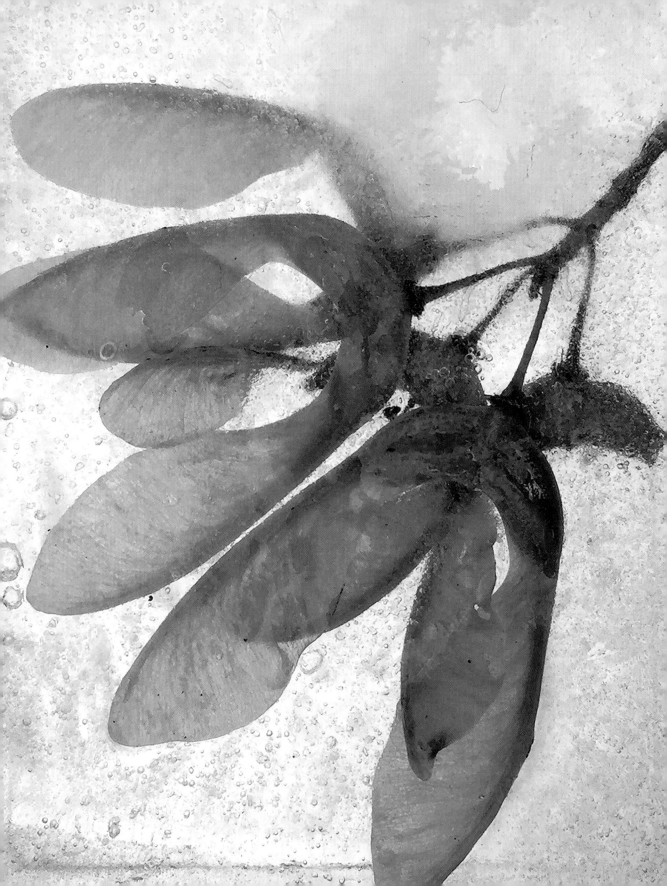

A still life indeed. Capture and freeze your nature trail in blocks of ice using a straight-sided container or ice-cube tray.

Put a thin layer of water in the base of your container and place your piece of nature in position. Pop it in the freezer to set. This first stage is to keep it in position and stop it from floating. Now remove it from the freezer and fill the container with water and freeze again. Remove, stack and photograph as you wish.

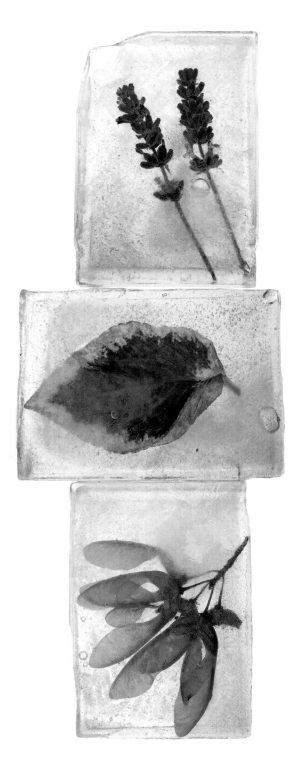

Tips for ice art:

1. Use boiled water for a clearer finish to your ice.

2. Continue to photograph at different stages of melting. The bubbles in the melting ice add texture to the frozen surface.

3. Photograph outdoors – hold your block up to the sky to reveal the bubbly, patchy, cloudy background.

4. Use your cubes to build a sculpture – but work quickly before it melts!

5. Fruit makes a good alternative to leaves and flowers. Keep it natural.

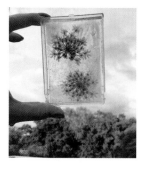

frozen
(leaves, ice)

#30. urban tape

Brief:

There are lots of different tape-art approaches. This project looks at <u>taping directly onto an urban surface</u>, photographing your artwork and then removing it without a trace. Create a mural and explore an idea. Look for an interesting canvas. It could be a corner, the pavement, a brick wall. Let the space itself spark an idea. Decide whether your work will be figurative or abstract, or maybe try and create an illusion (see page 18).

When you find the perfect surface to tape, first sketch out your arrangement on a notepad, then choose the appropriate tape, thinking about the colour, thickness and quantity you need. Then with scissors, tape and a sketch to follow, start your tape art!

"THE WORLD IS BUT A CANVAS FOR OUR IMAGINATION."

John Muir

Simple but bold ideas are the best... and if you can inject a bit of humour - all the better.

Maybe add a model to bring your art to life.

opposite: falling
(fluorescent tape, wall, model)

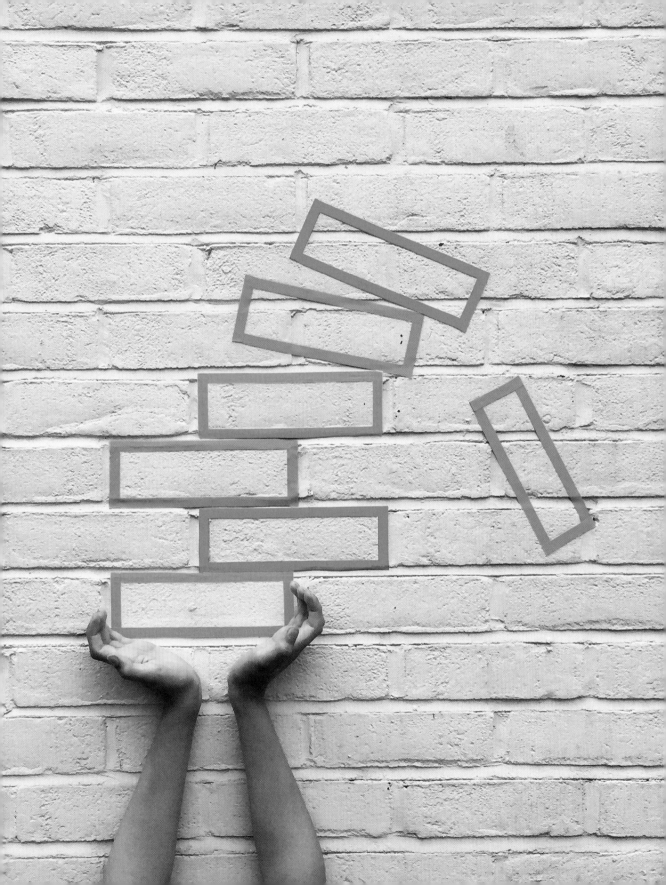

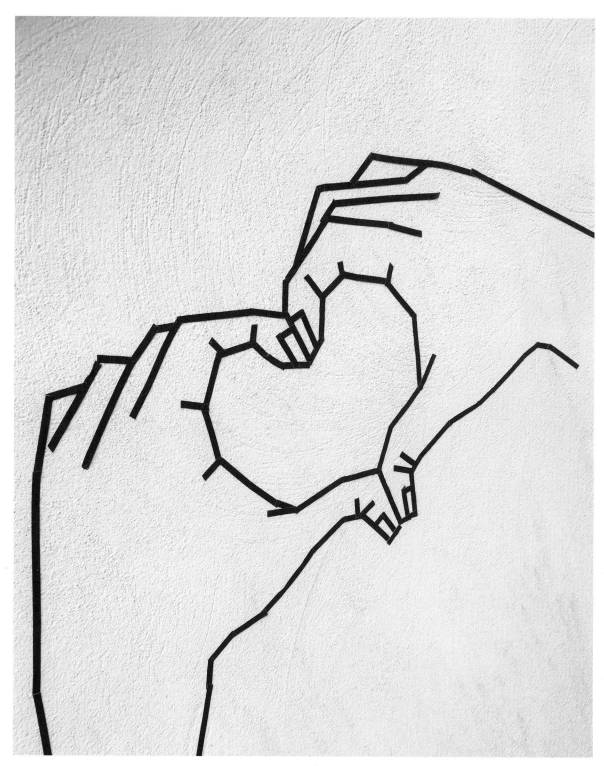

above: love you
opposite: spill

(tape)

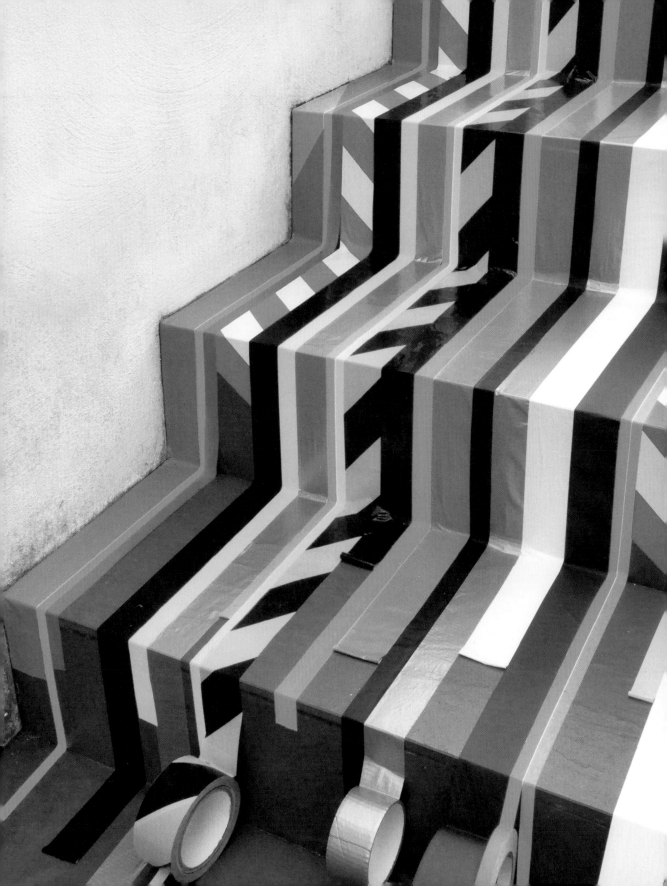

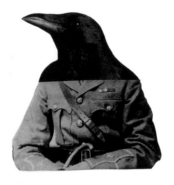

image credits

All artworks by Bev Speight unless otherwise stated.

All photography by Bev Speight except for David Midgley on pages 21, 23, 63, 97 and 105, and Verity Reeves pages 89 and 122.

thank yous

A big thanks to these lovely people for making this book possible - in no particular order...

My agent, Chelsey Fox, for her support and guidance; my fabulous family for their love and encouragement; my dear friend Liz Dean for her magical words; the very talented contributing artists - Archie Midgley, Alfie McMeeking, Cath Speight, David Midgley, Laura Grigson, Verity Reeves, Manako Gurung, Ishaa lobo, Pippa Beck and Chloe Price; The wonderfully creative team at Ilex - Roly Allen, Helen Rochester, Julie Weir, Meskerem Berhane and Rachel Silverlight; and my loving parents Brenda and Tony Speight to whom I'm dedicating this book.

about the author

I am passionate about art. A graphic designer, illustrator
and art educator, I started out at London design agency
Michael Peters, then worked for the BBC and HarperCollins
Publishers before co-founding design partnership XAB.
Now an independent creative, my projects include corporate
identity, branding and promotional design, book illustration
and photographic art direction.

I balance my time between my creative design practice,
university and making books.

For the last seven years I've been working with students on
the pre-BA Art Foundation courses at Middlesex University,
London, running the Intensive Foundation programme and now the
Foundation Year programmes. The projects I design for these
programmes emphasise research, collecting, experimentations
and being inspired so creativity flows - and it becomes fun.

I also work with young students on the National Art and Design
Saturday Club at Middlesex University, which I structure in
a similar way to the foundation courses, offering a variety
of experimental projects to get them excited about art
and design.

Feedback from the programmes and parents, asking if there
was a similar course opportunity for artists wishing to
develop their love of art, inspired me to write this book.
I love guiding others to explore the world as artists, and
to create work that they never expected from themselves.

"A GOOD ARTIST HAS LESS TIME THAN IDEAS."

Martin Kippenberger